DRAWING
DIGITAL

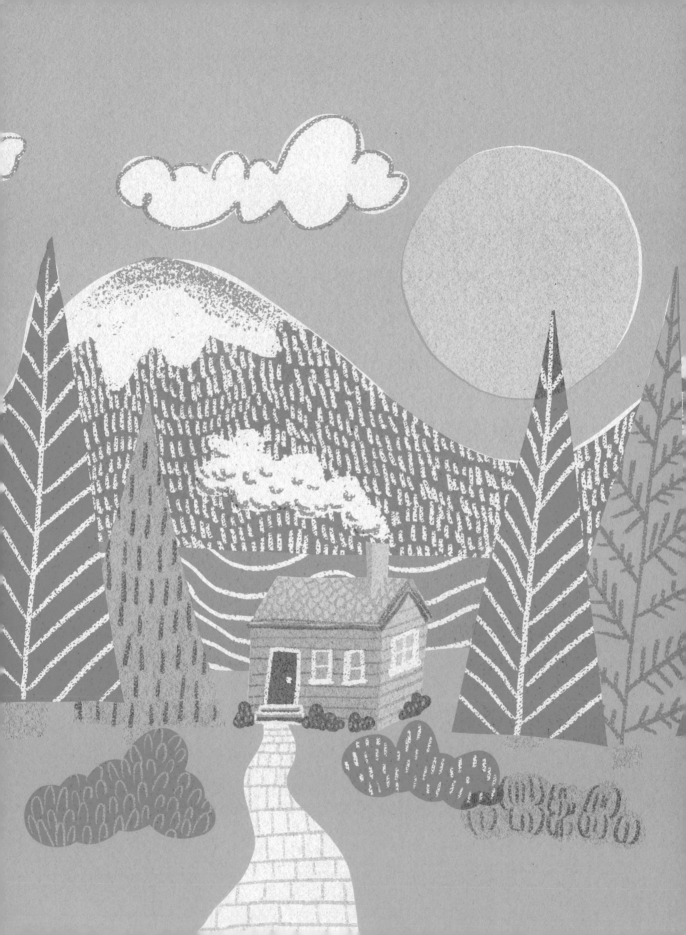

DRAWING
DIGITAL

The **COMPLETE GUIDE** for learning to **DRAW & PAINT ON YOUR IPAD**

LISA BARDOT

Quarto.com • WalterFoster.com

100 Cummings Center, Suite 265D, Beverly, MA 01915, USA.
T (978) 282-9590 F (978) 283-2742

First published in Great Britain in 2023 by Ilex,
an imprint of Octopus Publishing Group Ltd
Carmelite House
50 Victoria Embankment
London EC4Y 0DZ
www.octopusbooks.co.uk

An Hachette UK Company
www.hachette.co.uk

Walter Foster Publishing titles are also available at discount for retail, wholesale, promotional,
and bulk purchase. For details, contact the Special Sales Manager by email at specialsales@
quarto.com or by mail at The Quarto Group, Attn: Special Sales Manager, 100 Cummings
Center, Suite 265D, Beverly, MA 01915, USA. ·

27 26 25 24 23 1 2 3 4 5

ISBN: 978-0-7603-8532-6

Commissioning Editor: Ellie Corbett
Copy Editor: Ben Hawkins
Proofreader: Tara O'Sullivan
Indexer: Dr Laurence Errington
Editorial Assistant: Jeannie Stanley
Art Director: Ben Gardiner
Layout: JC Lanaway
Illustrator: Lisa Bardot
Senior Production Manager: Peter Hunt

Printed in China

Contents

Introduction

Hi, I'm Lisa Bardot!

Ever since I was able to hold a marker and a pair of scissors, I've been doing every craft imaginable: making my own toys, sewing with my mom, woodworking with my dad, and being creative in any way I could, from painting, photography, and printmaking, to ceramics, calligraphy, and creating films. But through it all, illustration has always held a special place in my heart and I dreamed of having the skills to create images from my imagination. Even though I'd always wanted to learn how to draw, I hated making grayscale pencil sketches. The magic of creating I'd fallen in love with through other artistic endeavors was just not there. So despite my desire, I gave up again and again... until I met the Procreate app.

I had just become a new mother, and I could see my creative self slipping away from me in the joy and chaos of caring for a newborn. I was desperately missing my creative outlets, which were too cumbersome to undertake given my current circumstances. When my husband gifted me my first iPad, I quickly discovered I could use it for drawing and was instantly hooked. In between the stress, mess, and exhaustion, it was such a relief to plop down on my sofa and play with the different colors and brushes. I drew animals for my infant son, which hang in frames on his bedroom wall to this day. As I began to explore this new art form, I felt a strong pull toward my dreams of being an illustrator.

So to develop those skills and find my identity as an artist, I made a goal to draw something every day for one year.

During that year, I became pregnant again and was suffering from severe depression. But I continued to draw as much as I could, and it became clear how important drawing was to my emotional well-being. In my postpartum days, drawing was a cathartic way to cope with or celebrate everything I was going through, and in sharing these drawings, I found a way to connect with others.

My digital drawing habit inspired me to start developing my own custom Procreate brushes, which I eventually began selling through my business Bardot Brush. The brushes prompted me to teach people how to use them, so I started making tutorials, too! Since then, I've taught millions of people around the world how to find their creativity through drawing on the iPad. In an effort to share with others the value of daily artmaking, I established the Making Art Everyday project: a series of daily drawing prompts, tutorials, and motivation to help people overcome creative fears and develop their art practice. And a few years later, I opened the virtual doors to Art Maker's Club, a joy-filled creative community and learning hub for digital artmakers. It's been the greatest pleasure of my career to share the magic of making art with others.

Why Draw Digitally?

Thanks to today's technology, learning illustration and creating art digitally is easier than ever. At its core, digital art is art. An iPad is just another tool in a long line of art media technology that has developed since the first cave paintings. Digital art is just as 'real' as pencils, markers, oil paints, and acrylics. In terms of learning to draw, the iPad is the perfect tool. It can be taken with you just about anywhere for opportunistic drawing practice, it doesn't require a lot of supplies and setting up, you don't have to worry about wasting paper, and you can set it down or pick it up at any moment, making it a convenient option for our busy modern lives. Not only that, but you also have a wide variety of art media, every available color, and the opportunity to experiment with limitless artistic styles right at your fingertips.

This book is for anyone who wants to use drawing to pursue a creative practice, tell stories, convey their emotions, or express themselves visually. Drawing is a skill that can be cultivated through practice, and I hope to fill that process with fun and color, while unlocking your creativity. In this book, you'll learn the basics of line, shape, form, and value, as well as digital art essentials, color theory, shading, proportions, and more. Each topic is covered progressively, so your skills will build over time. As you get to later chapters and projects, you'll apply skills you learned previously, culminating in crafting entire scenes by the end of the book. I also emphasize developing your own artistic style, with tips and exercises to help you stylize any subject and showcase your unique aesthetic.

In no time at all, drawing on an iPad will feel as natural as picking up a notebook and pencil, and you'll be creating colorful illustrations and unique works of art.

1
Getting Set Up

Years ago, before the invention of the iPad, I wanted to learn digital illustration so I bought a drawing tablet—a grey pad that hooks up to a computer and allows you to draw with a stylus in the same way you'd use a mouse. There was such a disconnect between what I was doing with my hands and what was happening on the screen that I abandoned my attempt. It wasn't until I got my iPad Pro and Apple Pencil that I realized how much the tools we use can help or hinder the process of creating art.

The experience of making art matters just as much (if not more) than the results. I love drawing on my iPad, and all the skills I've developed as an illustrator can be attributed to that: I love it, so I do it a lot, giving myself ample opportunity to learn, experiment, and grow as an artist.

This chapter is the exciting first step on your digital drawing journey, and will introduce you to the tools and software you'll need to begin making art with this modern medium. It is my sincere hope that these tools will resonate with you as they did with me—and that you find as much joy in digital artmaking as I do.

Tools: Hardware & Software

Digital art can be created on computers, tablets, and even smartphones, and there is a wide array of software and apps available. It may be difficult to know where to start. I suggest choosing the tools and software that will cause you the most enjoyment and, almost as importantly, the least frustration. Frustrations may be what cause you to give up on drawing—I know, because I have experienced this in my own journey as an artist. In the end, it's all about making it easy for you to make art and improve your skills.

Hardware

In this book, we'll primarily be using the Procreate app. As of this writing, Procreate is only being developed for iOS, so you'd need an iPad to use it. Apple makes four different iPads: iPad, iPad mini, iPad Air, and iPad Pro. Any of these devices would be excellent for creating digital art, but there are some considerations to make as you are deciding which iPad is the best for you.

The amount of RAM in an iPad is important for the performance of apps, especially in Procreate, as it determines the number of layers available for use. More RAM means more layers, providing a clear advantage in terms of creative flexibility. The iPad Air and iPad Pro have the most RAM and therfore offer the most layers.

Another consideration is screen size. I like to use a large screen, but some people may want a smaller device for portability.

You may also want to consider storage capacity. A larger hard drive means more room to store your artwork files. If your budget allows, go for a larger hard drive.

Finally, check the stylus compatibility of your iPad. You can't get a better stylus for drawing or painting on the iPad than the Apple Pencil. In fact, Procreate was developed specifically to work with the Apple Pencil. All new iPad models are Apple Pencil compatible, but older models may not be, so be sure to check Apple Support to see if your model is.

NOTE: Start your digital drawing journey using what you have for now and work your way up the technology ladder as you go.

Tablets

Accessories

You don't need much to get started with digital drawing, but here are three must-have accessories.

Firstly, as discussed above, the Apple Pencil is, by far, the best stylus for drawing and painting, and it's your most essential accessory. Brush size, opacity, and a variety of other Procreate brush settings are controlled by the Apple Pencil's unmatched pressure and tilt sensitivities. The Apple Pencil offers the most natural drawing experience.

Secondly, I highly recommend using a screen protector when drawing on an iPad. Using the Apple Pencil on a bare glass screen can feel slippery or sticky. I use a matte glass screen protector, which gives a smooth, buttery drawing feel; plus, it's anti-glare, which eliminates distracting reflections.

Finally, it is usually more comfortable to draw when the iPad is at an angle versus flat on a surface. Get a case with a built-in ability to angle the iPad. A case will also protect the body and screen of your device, which is very important as well.

Software

There is a wide range of painting and drawing apps and programs on the market, and as the industry and user base grow, new programs are coming on to the scene regularly.

Popular apps for digital art

- Procreate
- Adobe Photoshop
- Adobe Fresco
- ArtRage
- ibis Paint
- Clip Studio Paint
- Autodesk Sketchbook
- Art Set
- Infinite Painter

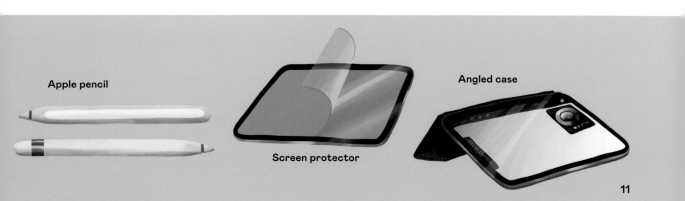

Apple pencil

Screen protector

Angled case

Spotlight on Procreate

 This book focuses on learning to draw in the Procreate app, but many of the concepts you'll learn are fundamental to drawing and digital art, and you can apply them to other apps, programs, or even traditional pencil-and-paper drawing. With that said, Procreate remains one of the most affordable and popular options for digital drawing apps. Despite being powerful enough for professionals, the interface is simple enough for beginners, so you can focus on making art instead of getting bogged down in endless options and menus.

Procreate Basics

Procreate is a drawing and painting app for iOS that has captured the artmaking world's attention thanks to its innovation, ease of use, and accessibility, making it the perfect software for people like you who want to learn how to draw digitally. Before you start drawing, you'll want to familiarize yourself with the Procreate interface and some of the tools and features you'll use throughout this book. Feel free to revisit the following pages whenever you need a refresher.

Gallery View

The first time you open Procreate, you'll be greeted with the Gallery View. Here, you can open and organize your existing artwork or create a new canvas by tapping the '+' sign on the top right, revealing a list of canvas templates.

Create a new canvas

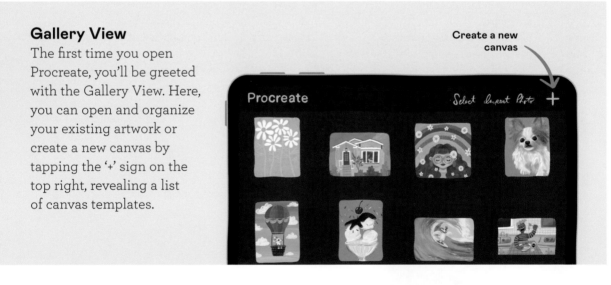

Choosing a Canvas Template

'Screen size' is a great option for sketching and practice, but for general artwork, I'd suggest making your own canvas template by tapping this icon. After opening a canvas template, you'll see the Procreate interface.

For more about canvas size and resolution, see pages 22–23.

Procreate Interface

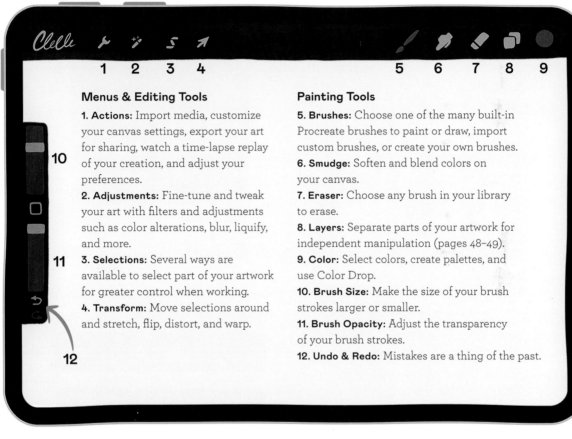

Menus & Editing Tools

1. Actions: Import media, customize your canvas settings, export your art for sharing, watch a time-lapse replay of your creation, and adjust your preferences.

2. Adjustments: Fine-tune and tweak your art with filters and adjustments such as color alterations, blur, liquify, and more.

3. Selections: Several ways are available to select part of your artwork for greater control when working.

4. Transform: Move selections around and stretch, flip, distort, and warp.

Painting Tools

5. Brushes: Choose one of the many built-in Procreate brushes to paint or draw, import custom brushes, or create your own brushes.

6. Smudge: Soften and blend colors on your canvas.

7. Eraser: Choose any brush in your library to erase.

8. Layers: Separate parts of your artwork for independent manipulation (pages 48–49).

9. Color: Select colors, create palettes, and use Color Drop.

10. Brush Size: Make the size of your brush strokes larger or smaller.

11. Brush Opacity: Adjust the transparency of your brush strokes.

12. Undo & Redo: Mistakes are a thing of the past.

NOTE: The software features presented in this book are up to date at the time of writing. Things may look a little different if you're reading this in the future (if you are, your past self says hi, and they're so proud of you!).

Brush Library

Tap the paintbrush icon to access a wide variety of brushes to use in your digital art. Here you can choose from the pre-installed default brushes, import third-party brushes, or create your own.

1. Brushes are organized into sets.

2. Tap the selected brush to access the Brush Studio, where you can edit brush settings or create your own brushes.

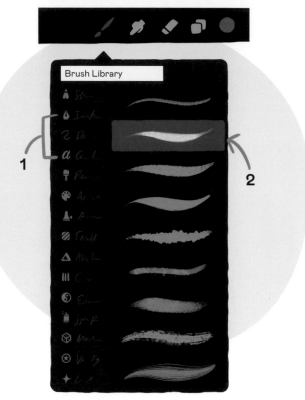

Explore brushes on pages 44–47

Layers Panel

The two squares icon will open the layers panel which you can use to create separated parts of your artwork, adjust layer opacity, set blend modes, and change the background color.

1. You can only draw on or modify the selected layer, highlighted in blue. Tap to open the Layer Options Menu to select, clear, create masks, and more.

2. See a thumbnail of the layer's contents.

3. Tap the '+' to create a new layer.

4. Uncheck the box to hide a layer.

5. Tap this letter to change the layer's opacity or blend mode.

6. Tap 'Background Color' to change it.

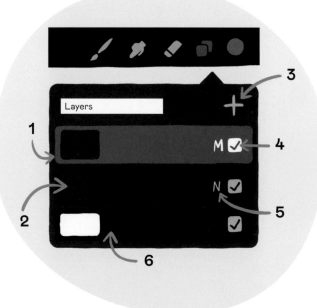

Learn all about layers in Chapter 3

Colors Panel

Tap the circle in the upper-right corner to open the colors panel. Select colors using several modes and create color palettes.

1. To choose a color, first select a hue . . .

2. . . . then set the color's saturation and brightness.

3. There are several modes for selecting colors.

4. Primary and secondary colors.

5. Save colors in a palette here.

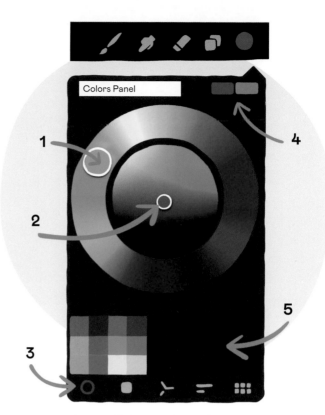

Learn all about color in Chapter 4

Fill Shapes with Color Drop

Drag the Color Panel circle into a closed shape to quickly fill with color.

Adjusting Color Drop Threshold

If color isn't completely filling the shape or spills out everywhere, you may need to adjust the Color Drop Threshold. Fill a shape using the Color Drop tool, but don't lift your stylus or finger. Without lifting off the screen, drag to the left or right to adjust how much color spills into other areas.

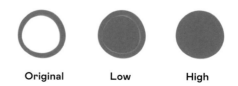

Original Low High

Essential Gestures

As a touch-based application, Procreate is primarily controlled with gestures. Tap, twist, swipe, spread, pinch, and scrub—indispensable controls are at your fingertips.

It won't take long for these gestures to become second nature as you continue to use Procreate. In fact, Procreate users often find themselves unknowingly tapping and swiping their paper sketchbooks!

Undo
Two-finger tap.

Redo
Three-finger tap.

Tap and hold these gestures to continuously undo/redo.

Interface Gestures

Zoom & Rotate Canvas
Two-finger pinch, spread, and rotate.

Clear Layer or Selection
Three-finger back-and-forth 'scrub.'

Copy/Paste Menu
Three-finger swipe down.

Eraser & Smudge Quick Select
Tap and hold the Eraser tool icon. Whatever brush you were using to paint will be used for the Eraser, ensuring consistency in texture between eraser and brush marks. This gesture also works with Smudge.

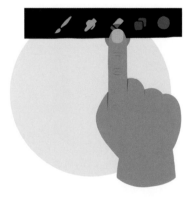

Color Gestures

Previous Color
Tap and hold the Color Panel circle to switch to your last-used color.

Select Color
One-finger tap and hold to select colors from the canvas.

Color Snapping
Double-tap around the color disc to get pure-value colors such as pure black or white.

Layer Gestures

One-finger gestures

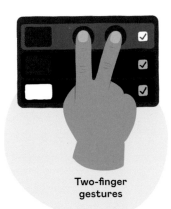

Two-finger gestures

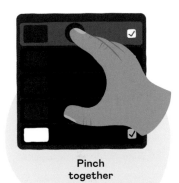

Pinch together

Reorder Layers
Tap and hold, then drag a layer into the desired position.

Select Multiple Layers
Select multiple layers by swiping right on each one.

Delete or Duplicate a Layer
Swipe left on a layer for options to delete or duplicate the layer.

Enable Alpha Lock
Swipe right over a layer with two fingers (learn more on page 52).

Select Layer Contents
Two-finger tap and hold on a layer to select its contents.

Quick Layer Opacity
Two-finger tap on a layer, then slide your finger left or right on the canvas to adjust layer opacity.

Merge Layers
Pinch together two or more layers to merge them into one.

Selections

With Selections, you can isolate portions of your artwork to modify, transform, adjust, and alter with precision.

There are four selection modes: Automatic, Freehand, Rectangle, and Ellipse. Let's look at the Freehand mode.

Making a Freehand Selection

1. Draw or tap around the area you want to select.

2. Tap the gray circle to close the selection.

3. A selection mask will appear, allowing you to see your selection.

You can modify your selection using the options in the Selection toolbar.

More Selection Options

Automatic: Select an entire similarly colored area. Tap and hold into an area of color, then slide left or right to adjust the threshold of the selection. Tap in other areas to add to your selection.

Invert: Reverse the inside and outside of your selection.

Feather: Blur or soften the edges of your selection. A higher percentage means softer edges.

Save & Load: Save a selection to recall later.

Color Fill: Enabling this option will automatically fill your selection with color. Change the fill color in the Color Panel.

Transform

With the Transform tool, you can easily move and manipulate a selection, to reposition, rotate, flip, warp, or distort it as you wish.

Move

Scale & rotate

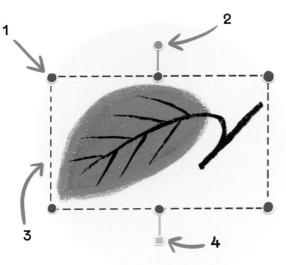

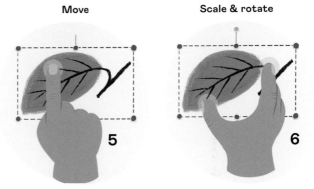

1. The bounding box shows the boundaries of your selection.
2. Tap and drag the blue transformation node dots to resize or distort.
3. Drag the green node to rotate.
4. Use this yellow node to rotate the bounding box to best fit your selection.
5. Drag inside or outside the bounding box to reposition your selection.
6. Pinch, spread, or rotate inside the bounding box to scale or rotate your selection.

Transformation Modes

Transform modes and tools you can use to resize or distort your selection

 Freeform: Change the horizontal or vertical size independently.

 Uniform: Make the selection bigger or smaller without distortion.

 Distort: Shear the selection—useful for altering perspective.

 Warp: Distort the text organically by dragging the grid.

 Snapping & Magnetics: Enable to use guides as you reposition.

 Flipping: Mirror your selection horizontally or vertically.

 Interpolation: Control how pixels are affected when transforming.

Exporting & File Formats

Once you have finished your artwork, you can share it in a variety of file formats. To export your artwork, go to the Actions menu (Actions>Share). Let's look at the different options and why you might choose each. These file formats fall into two categories: formats that preserve your layers and formats that flatten your artwork into a single layer.

Actions Icon

File Formats that Preserve Layers

These formats keep your artwork editable and are great for backing up your artwork.

Procreate—Keep it Native

Using the .procreate format ensures that all the data associated with your artwork is preserved. With this format, you can back up your work or move it to another iPad running Procreate, and everything will be exactly the same.

PSD—Photoshop Compatible

The .psd format converts your Procreate artwork into an editable file compatible with Adobe Photoshop. This format preserves your layers, layer names, opacity, visibility, and blend modes.

File Formats that Flatten

Use one of these formats for sharing your work on the web or when printing.

JPEG—Compact & Convenient
Since .jpeg is the most common file format, it is universally compatible. It uses compression to reduce the file size, but as a result, there is a loss of quality.

TIFF—High-Quality Printing
The .tiff format has the highest image quality, hence the largest file size, and is commonly used for printing.

PNG—Quality with Transparency
With a .png, 'lossless' compression preserves full image quality, making the file a little on the larger side. This format also supports transparency, so is ideal for pieces with transparent backgrounds.

PDF—Popular & Print-Friendly
The .pdf format is a very common digital media format that is widely accepted by print houses and publishing companies.

Which File Format Should I Use?

For most purposes, it is best to export your artwork in .png format. It's compatible with sharing on the web, it's high quality for printing, and it supports transparency when you need that feature.

NOTE: If you plan to have your work printed, you should always check with the print house about what file format they prefer.

Printing & Resolution

What Size Should I Make my Canvas for Digital Art?

Every digital image is made up of tiny squares called pixels. Just as you'd measure a room in your home in feet or meters, you'd measure a digital image in pixels, width by height. The number of pixels in a digital image refers to the image's **resolution**.

Unlike inches or centimeters, which are always the same size, a pixel can be large or small.

Pixels Can Be Large

If something that looks 'pixelated', it means that very few, very large pixels are filling an area, meaning it's easy to see each pixel. The top circle (see opposite page) is an example of a low-resolution image.

Pixels Can Be Small

When a ton of tiny pixels are crammed into that same amount of space, you can't see the individual pixels, and the image looks smooth and clean. The bottom circle is an example of a high-resolution image.

For drawing practice or general artmaking, I use the canvas sizes below.

Vertically Oriented Canvas:
3,800 × 2,000 pixels
Horizontally Oriented Canvas:
2,800 × 3,500 pixels

If you have specific needs or intentions for your art, you might want to read on to learn the ins and outs of resolution to decide what size canvas you should make.

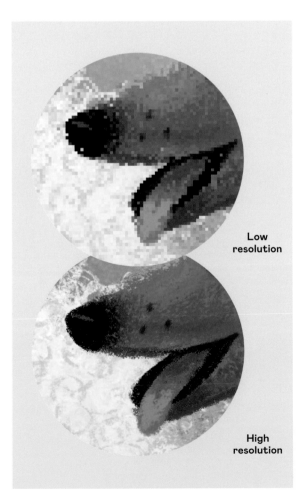

Low resolution

High resolution

High Res for Happier Artmaking

When creating digital art, there are a lot of reasons why you don't want to work with a canvas that is too small. You'll run into problems like transformation degradation (jagged or blurred edges after moving objects around) or pixelation problems when trying to upscale low-res work.

Is Bigger Really Better?

However, working with an extremely high-resolution canvas might cause performance issues (i.e. slowness). When working in Procreate, a super high-resolution canvas presents another obstacle: hitting your layer limit. You'll get to know layers better in Chapter 3, but layers make your digital artmaking life easier in a number of ways, so the more layers you have to work with, the better. As discussed on page 10, Procreate places limits on maximum available layers depending on your iPad hardware, but also canvas resolution. The bigger the canvas, the fewer layers you'll have to work with.

General Guidelines for Creating Canvases

To determine your canvas size, consider your intended use and make the canvas size a bit larger. I recommend working with a canvas no smaller than 2,000 pixels on the shortest side to avoid degradation effects. And when deciding how big to go, pay attention to how many layers are available. For pieces intended for print, make your canvas at least 300 pixels per physical inch.

2
Everyday Objects
Line & Shape

The best way to learn how to draw is to start with the fundamentals. This chapter will focus on the basics of line and shape—the building blocks of art. First, you'll warm up by doing line exercises to help you control your movements while drawing. Then you'll progress to using shapes to construct simple, everyday objects in two and three-dimensions.

Learn Your Lines

We'll begin by learning how to draw the most basic of art elements: the line. Mastering the ability to draw lines may sound too simple to be important, but it is the core skill of drawing. It's entirely normal for your lines to be wavy and wonky if you're new to drawing. They'll get smoother over time.

The following line exercises will help to build the fundamental skills you need to draw. They are also a great way to loosen up your hand, train your drawing muscles, and get your brain ready before a drawing session.

Select a Speed
Draw three sets of parallel lines. The goal is to get them as straight as possible and evenly parallel. Draw the first set nice and slow, the second set at medium speed, and the third set very fast.

 Which speed feels more comfortable and gives you the best results? Sometimes, drawing slowly and meticulously isn't the best. Repeat this exercise with wavy lines, again trying your best to keep the lines parallel. Did you find that the fast, wavy lines are more expressive and full of personality?

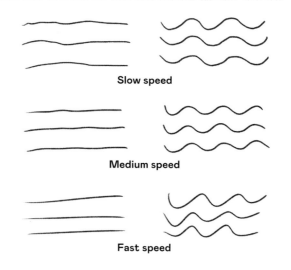

Slow speed

Medium speed

Fast speed

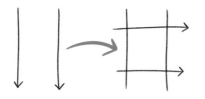

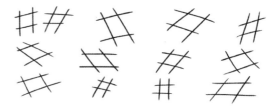

Parallelogrids
Draw two straight parallel lines, then draw two more parallel lines going the other way over the top of the first ones.

Do this at many different angles. As you do so, take note of what feels most comfortable to you: drawing lines up, down, left, or right.

Here are a few more exercises to try:

Hash Grids
Draw a series of parallel lines in one direction, then choose another direction and draw another set of parallel lines.

Rainbows
Draw a small arched line, then another line slightly above it, trying to keep the same distance between both lines.

Wavelengths
Draw an undulating line in a variety of wavelengths from tight to loose. See how long you can draw a continuous line.

Sketchy Swerves
Use very short sketchy lines to draw a curving line. Try very tight and wide curves. Does sketching feel more comfortable than drawing continuous lines?

Growing Spirals
Draw spiraling lines that grow or shrink with each loop. Experiment with drawing these fast and slow.

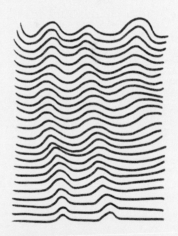

Follow-Me Lines
Draw a curving line at the top of your canvas. Right below it, try to draw a duplicate of the line you just drew. Then keep going. You might find that your line changes over time.

Simple Shapes Practice

Shapes are the building blocks of all other objects. Believe it or not, you can boil down everything you draw from here on out to a collection of shapes and lines. You'll start with a simple shape for everything you draw, then either add to or subtract from it to create complex objects. This concept will make more sense in the chapters to come, but for now, hone your shape-drawing skills with these simple exercises.

Shape Columns

At the top of your canvas, draw a circle, oval, square, rectangle, and two different triangles in a row. Then, in columns, draw each shape several times, trying to keep them all uniform.

Size-Up Shapes

Draw a row of a single shape, increasing its size as you go across. Practice this with many different shapes.

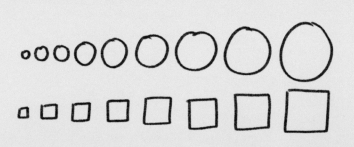

Concentric Shapes

Start with a small shape, then draw an outline around it, then another, and so on. Don't let any of the lines touch.

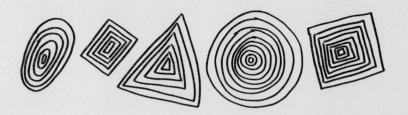

There's More Than One Way to Draw a Shape

If it's hard to draw a square, quickly draw two sets of parallel lines instead of one continuous line. Is it easier to draw a large square or a small square? Zoom in or out when you draw the shape.

If it's hard to draw a circle in one continuous stroke, draw several circles over and over very quickly. How many times do you lift your pencil when drawing a triangle? Two? One? None?

It may seem basic, but learning to draw these simple shapes in the way that works the best for you is going to lead to more success in your drawing down the line.

More Shapes to Practice

Semicircle
You'd be surprised at how often you only need half a circle.

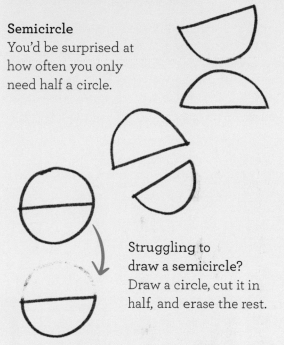

Struggling to draw a semicircle? Draw a circle, cut it in half, and erase the rest.

Organic Shapes

Not everything is geometric—be sure to practice organic shapes too. Beans are handy shapes to use when constructing objects.

Shape-Drawing Tips

Discover some useful digital art features that can help you out when drawing shapes.

QuickShape

Are the shapes you draw looking a little wonky and wobbly? Procreate's QuickShape feature can help you out. Draw a shape, such as a circle, but keep your stylus touching the screen. The shape will snap into an ellipse. This feature works with lines, arcs, rectangles, triangles, and more.

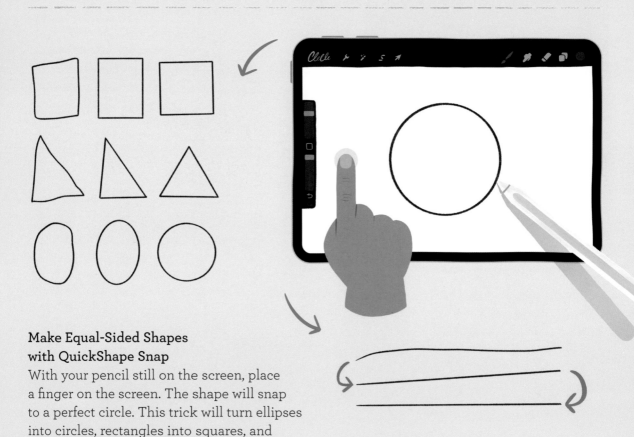

Make Equal-Sided Shapes with QuickShape Snap

With your pencil still on the screen, place a finger on the screen. The shape will snap to a perfect circle. This trick will turn ellipses into circles, rectangles into squares, and triangles into equilaterals.

QuickShape Snap will make lines snap to 15-degree increments, ideal for making perfectly horizontal or vertical lines.

Liquify

Sometimes, no matter how many times you draw and redraw a shape to get it right, part of it might be a little off. Go to the Adjustments menu (Magic Wand icon) and tap Liquify. Tap the 'Push' setting and use your stylus to gently move lines into place. Adjust the Size slider to make the perfect push. This is particularly useful for smoothing out irregular shapes. I use Liquify frequently to refine as I draw, especially in the sketching phase. Placing an element on a separate layer (which we'll discuss more in Chapter 3) makes it easy to use Liquify on only one shape or line without affecting anything else.

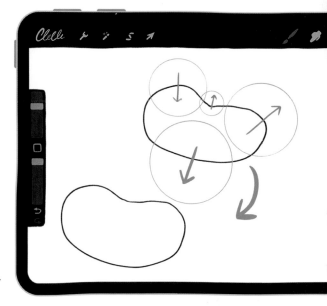

More Liquify Tips

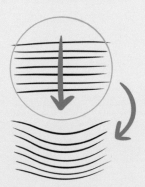

Push

Liquify can also make drawing certain things easier. Need a set of parallel lines that follow a curving contour, such as stripes on a shirt sleeve? Straight lines are easier to draw than curved ones, so start with a set of straight lines, then 'Push' them into a curved shape.

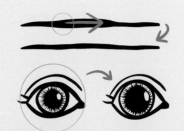

Pinch & Expand

There are several other Liquify modes, each producing its own effect when used. 'Pinch' is useful for selectively 'shrinking' areas of your work, such as reducing line weight. 'Expand' is great for making things bigger. I used 'Expand' to make the center of this eye bigger without changing the width. Learn how to draw facial features on pages 108–109.

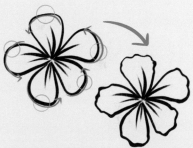

Organic Ripples

You can add organic ripples to your artwork, like the ones on this flower, by using the 'Twirl' mode with the Distortion slider turned up. Learn how to draw flowers in Chapter 4.

NOTE: Be aware that there is some degradation of quality when you push pixels around the canvas. So don't overuse Liquify, especially on your final artwork (if it's a sketch, go wild!).

How Shapes Become Stuff

Alright, I'm with you. Drawing shapes is a little boring. You wanted to learn to draw so you could actually draw stuff, right? Let's get into that next.

All you need to do is add some lines to a shape and it becomes something else. Drawing shapes IS easy, and that's precisely why we use shapes as the building blocks of an illustration. It's much easier to draw a shape and add details to it, than it is to draw something with precise details all at once. This process of drawing complex subjects using basic shapes is called **construction**.

Let's begin by drawing some simple objects out of basic shapes.

In digital art, you can use layers and the opacity adjustment to your advantage. Draw the outline of the basic shape. In the Layers panel, reduce the opacity of the layer containing the shape. Then create a new layer on top, and draw your chosen object using the base shape as a guide. Add extra curves and details until you have the object!

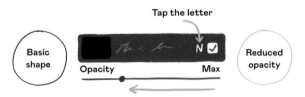

Turn the slider down to reduce the layer's opacity

Then create a new layer on top, and draw the object using the base shape as a guide. Add extra curves and details until it's finished!

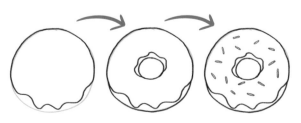

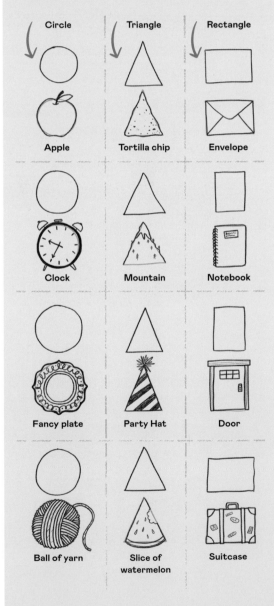

Try this
Draw a series of simple shapes on your canvas and imagine what they could become.

Circle	Triangle	Rectangle
Apple	Tortilla chip	Envelope
Clock	Mountain	Notebook
Fancy plate	Party Hat	Door
Ball of yarn	Slice of watermelon	Suitcase

2D Shape Combos

You can combine more than one shape to make more complex objects. Constructing a subject from basic shapes is fundamental to drawing. Even the most intricate of subjects can begin as circles and rectangles, as you'll see in the more advanced sections of this book.

TIP: Drawing round shapes within a rectangle can be easier than drawing them outright

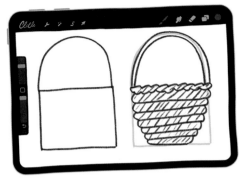

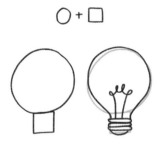

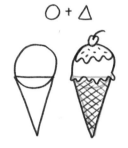

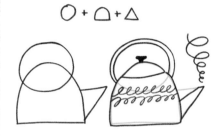

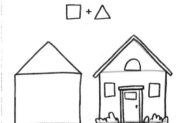

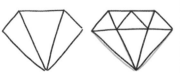

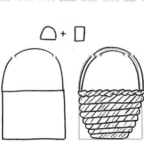

Making 3D Forms

Using 2D shapes is the simplest way to construct a drawing, but if you need to draw an object in perspective, from an angle, or as though it has volume, you should use 3D forms. When it comes to lighting and shading, 3D forms are extremely helpful, since they allow you to visualize how light can fall on or wrap around an object. In drawing, 3D forms are essential to construction.

2D to 3D

There are a few basic 3D forms that can be born of 2D shapes:

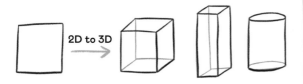

A flat quadrilateral can become a cube, rectangular prism, or cylinder.

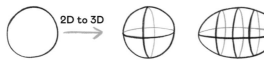

A circular shape can become a sphere or ellipsoid.

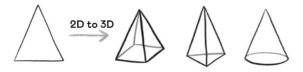

A triangle can become a cone or pyramid.

3D Vocabulary

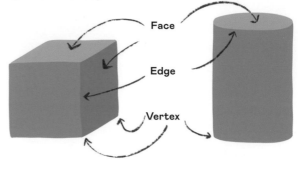

When drawing a cube or rectangular prism, pay attention to your parallels. Draw one face, and extend parallel lines from each vertex, or corner. Connect the ends of these lines together, keeping the new edges parallel to the edges of the original face.

You can also use this method to draw other 3D forms. Practice drawing the 3D forms below.

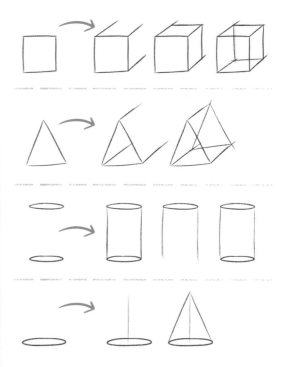

Irregular 3D Forms

You can make irregular shapes into 3D forms as well. Here are a few ways to do so:

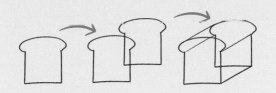

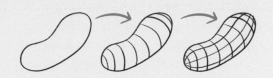

Extrude

Start with a 2D shape—this is one face of the form to be. Duplicate or redraw that shape a certain distance away. Draw parallel lines connecting the same corners on each of the shapes.

Contour Lines

Using curved or concentric lines, you can express the volume of a rounded form. These are called contour lines. Draw contour lines along the horizontal and vertical axes.

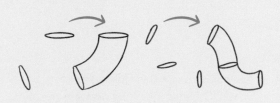

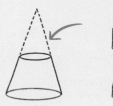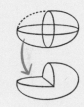

Curved Edges

A tube is another irregular shape that is highly useful in drawing construction. Draw two differently angled ellipses and connect the vertices with curved lines. A tube can become an arm or a macaroni noodle.

Subtracting

In many instances, you only need part of a 3D form to construct an object. For example, a cone with the top cut off (a tapered cylinder) or a hemisphere (half-sphere). Start by drawing the full 3D form, then intersect and erase the unnecessary edges or corners.

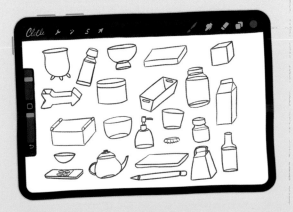

3D Forms Practice

Observe your surroundings. What 3D forms can you identify in the objects you see? Are they regular or irregular? Spend some time filling up a canvas with the 3D forms you see around you.

From Forms into 3D Objects

Once you have created a basic 3D form, it's pretty simple to turn it into an object. Understanding the structure of a 3D form gives you valuable information about how to draw everything else in that object.

For example, this cylinder can become a soup can. On the top face of the cylinder, a few concentric ovals can represent the ridges on the top of the can. And when drawing the label, it can follow the same curve as the top oval of the cylinder.

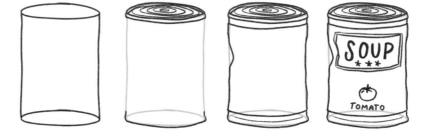

Simple Objects

Draw a few simple objects using a single 3D form. What other things can you draw with only one 3D form?

3D Form Combos

As with the 2D shapes on page 33, you can combine 3D forms to create more complex objects.

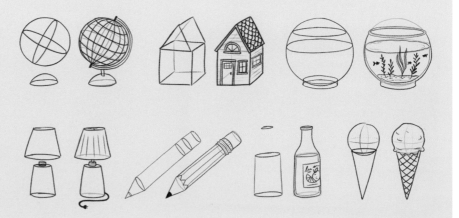

Divide & Conquer

Dividing a 3D form into sections will help immensely with the placement of details. For example, draw an acorn like the one here, and notice how the guidelines that divide up the cap help you draw the acorn's scales.

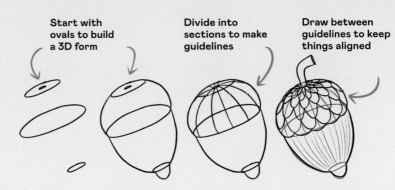

Start with ovals to build a 3D form

Divide into sections to make guidelines

Draw between guidelines to keep things aligned

Irregular Objects

Not sure which 3D forms make up a particular object? Start with one or two faces of the object, like the sole and opening of this shoe. Add another line for height or volume, then connect.

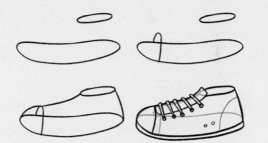

Draw Some Objects

Here is a list of objects to draw. Think about what 3D form(s) you would need to construct each item. Draw the 3D forms very lightly, then go over them with more detailed lines and curves to draw the object.

- Cereal box
- Vase
- Teacup
- Purse
- Toothpaste tube
- Hairbrush
- Basket

- Cupcake
- Milk carton
- Backpack
- Bowl
- Camera
- Alarm clock
- Hat

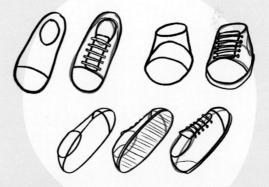

You can even use the same construction lines to draw an object from different angles, depending on the details you add. With one structure, you can draw this shoe from above or below.

Project: Still-Life Sketch

Get ready to draw some of your favorite personal items using your new drawing skills. In this project, you'll be applying your knowledge of creating objects using 2D shapes and 3D forms, and learning how to create a detailed scene by breaking it down into manageable steps.

Collect Some Objects

Gather some everyday objects from around your house, for example:

Bottle, vase, cup, mug or other drinkware, bowl, pitcher, fruit or other food items, dishes, candles, boxes/packaging, books.

Make sure you choose objects that are simple in form, so you don't get overwhelmed by trying to depict something overly challenging.

Set Up Your Still-Life Scene

Stack and layer your objects to create an arrangement. It can be helpful to take a photo of your still-life scene, but keep the real-life set-up next to you while you sketch. Be sure to look at your still-life set-up often as you work. Before drawing anything, look at each item and imagine what 3D form you might use to draw it.

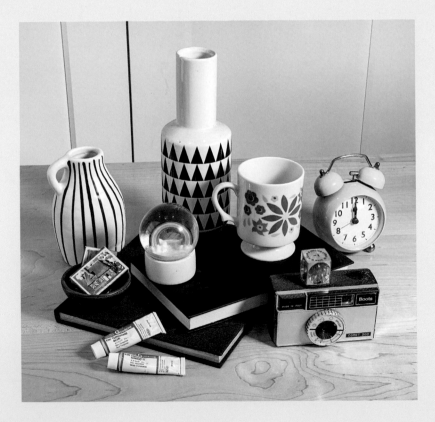

Draw Objects As 2D Shapes

1. The first step is to draw each of the objects as basic 2D shapes, such as circles, rectangles, etc. This step will give you a better sense of the overall shape and proportions of each item. In addition, it will help you lay out the scene, deciding where items overlap.

Draw Everything In 3D

2. Reduce the opacity of this 2D shape layer and create a new layer above it. On the new layer, you'll sketch each object in its simplified 3D form. It helps to start by drawing similarly shaped faces. In my example, I'm drawing the tops and bottoms of all the rounded objects. Notice how all the ovals are at a similar angle and height.

Connect Top & Bottom Faces

3. Now you can draw in the edges of those cylindrical forms. Continue to draw all the objects in 3D.

Tracing

If placing everything feels difficult, you can import a photo of your scene to your canvas and trace the basic shapes, but try not to rely on tracing the photo after this step.

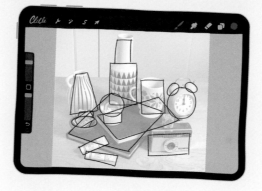

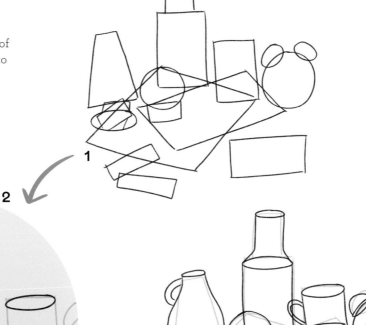

Check Your Parallels

4. Something to keep in mind is that all vertical lines should be parallel. If they aren't, the items could appear to be tilting or out of proportion.

Create the Final Sketch with Details

5. In the Layers panel, turn off your first sketch (2D shapes), and reduce the opacity of your 3D sketch. Create a new layer on top.

Then you can draw each object with all its unique details. Using the still-life set-up as a guide, trace each 3D form, adding extra curves and details. Draw the foreground items first, so you don't have to draw any parts of the background objects that aren't visible.

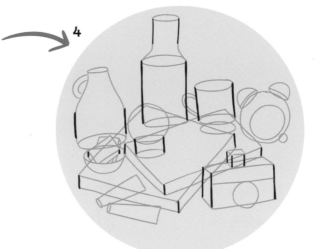

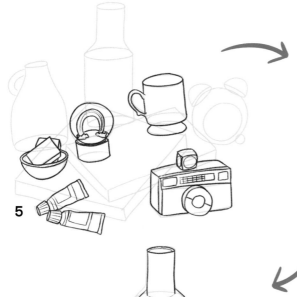

NOTE: Once you've finished drawing all the objects, you can go back and add some of the more decorative embellishments, if you like.

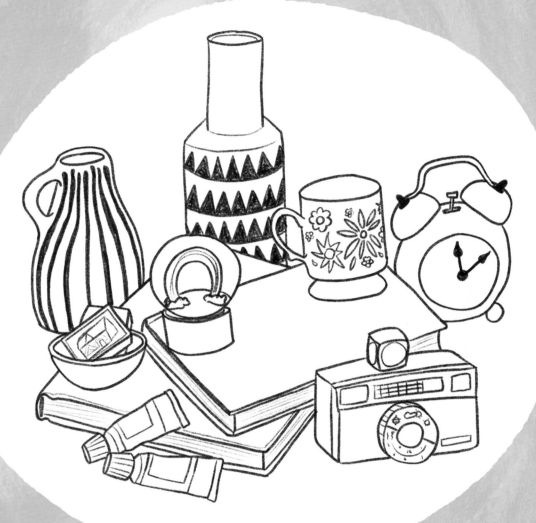

Admire Your Work!
Congratulations on your first piece.
Let's leave this as a pencil sketch for now, but
feel free to revisit this piece to add color and
rendering as you learn more later in the book.

3
Plants
Digital Art Essentials & Coloring

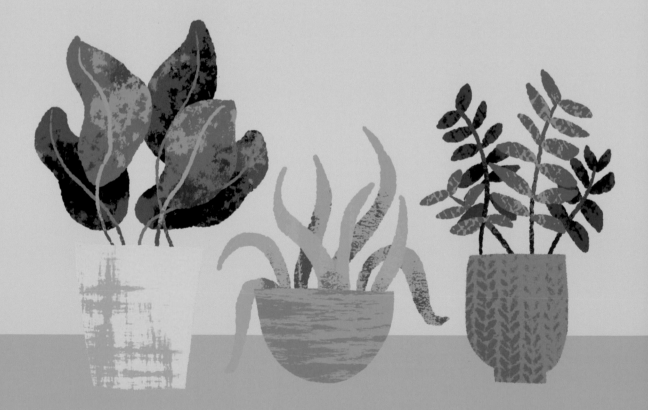

With your drawing skills honed, it's time to learn about the suite of digital art tools that will simplify and improve your creative process.

In this chapter, you will discover which brushes work best for which purposes, how to manipulate and experiment using layers, and how to control your drawing process with masks. You'll learn how to mix colors and apply lighting effects using blend modes, and you'll see how sketches become final artworks through rendering. Mastering your software and all its tools will unlock your imagination and allow you to create illustrations more quickly and easily.

Your technical expertise won't be the only thing that grows—as you explore these tools, you'll have a lot of fun drawing and coloring plants. Thanks to their organic shapes, drawing plants is very forgiving.

Let's get growing!

Brushes

No tool is more essential to a digital artist than brushes. In addition to being equipped with a set of default brushes, many digital art apps let users create and customize their own, so the number and types of brushes available to artists are as limitless as their imagination.

Many brushes are designed to emulate their real-world counterparts—like paint, markers, charcoals, pencils—but brushes can also have functions that are only possible when working digitally, such as changing colors, lightening or darkening, stamping shapes, creating effects like smoke and fire, and so much more.

TIP: Take notes as you work and identify the brushes that you prefer for specific purposes.

Brush Types

Pencils & Sketching Brushes

Pencils and other thin brushes with pressure and tilt sensitivity are great for sketching, as you want a brush that makes lighter marks when less pressure is used and allows you to shade when the Apple Pencil is tilted. Finding your go-to sketching brush is essential, so try out a few to see what works.

Procreate Brushes to Try: HB Pencil, 6B Pencil, Procreate Pencil, Peppermint

Sketch some vines: Draw curving lines and add different leaf shapes. Tilt your Apple Pencil to color in the leaves. Which brush feels most comfortable for sketching?

Shape-Making & Coloring Brushes

In colorized art, these brushes create the main shapes, so precision is key. Brushes that have pressure sensitivity affecting brush size will offer increased control over your strokes. A brush with an interesting edge texture can help you draw heavily textured subjects, such as fur and foliage, more quickly.

Procreate Brushes to Try: Studio Pen, Dry Ink, Blackburn, Evolve, Eaglehawk, Inka, Oberon, Copperhead

Simple Leaf Shapes: Make a leaf-shape outline and fill it with Color Drop, or color in the outline by hand, showing off the texture of the brush. Keep your eyes peeled for interesting textures. Which brushes give you the most control over your shapes?

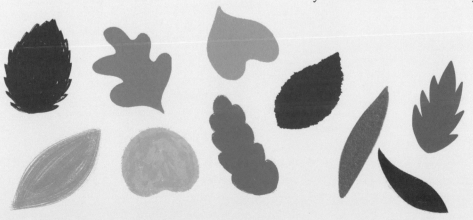

Texturizing Brushes

These brushes can add texture, shading, or highlights to a flat color area. They often feature a grain pattern and a soft or textured edge. You can densify the texture using heavier pressure with pressure-sensitive brushes, or by layering strokes.

Procreate brushes to try: Artist Crayon, Grunge, 6B Compressed, Burnt Tree, Hard Rain, Concrete Block

Make Bushy Blobs: Fill your canvas with a green background, then, using lighter or darker values, draw bush shapes using brushes of varying textures. Can you make the texture denser by using more pressure or layering strokes?

Painting & Blending Brushes

You can blend and smear colors and values together using these brushes due to their unique capabilities. These brushes can 'pull' colors around the canvas like wet paint, and may exhibit a bristle-like texture.

Procreate Brushes to Try: Oil Paint, Soft Shading*, Turpentine

Two-Tone Leaves: By using two shades of green, test the blendability of these brushes. Pick up your stylus several times to layer strokes as you blend and experiment with pressure.

Refining Your Shape

Refine your shape with the Eraser tool. Did you know you can select any brush in your library to use with the Eraser tool? Choose one to erase the paint blobs into a sharp leaf shape.

*Download a Free Procreate Brush!

As one of the leading independent brush makers for the Procreate app, I've developed brushes emulating a wide range of art media used by artists worldwide. Get my 'Soft Shading' blending brush for free at bardotbrush.com/book, and use it for projects in the People and Scenes chapters.

Linework & Detail Brushes

Brushes like these are excellent for fine details and some of the final touches on your digital art pieces. A thin brush, or one with an intriguing texture that works well at small sizes, would be ideal. Sketching brushes might serve double duty as detail brushes.

Procreate Brushes to Try: Shale, Little Pine, Kunanyi, Bamboo, Reed

Draw Leaf Veins: Use a shape-making brush to draw simple leaf shapes. In a darker green, draw the veins of the leaves. Experiment with speed and pressure. Try 'flicking' your stylus at the end of a stroke to create a tapered effect.

Specialty Brushes

This category contains brushes created to produce a specific visual or lighting effect, pattern, stamp, etc. But even brushes with a specific purpose can be used in creative ways, so don't write these off as one-trick ponies.

Procreate Brushes to Try: Wildgrass, Snow Gum, Swordgrass, Lightpen, Flower Power, Hessian

Play & Explore: Poke around the different brush sets and identify possible specialty brushes. There are even some great brushes that emulate greenery with a simple swipe of your pencil.

Layers

As we dive into the world of digital artmaking, let's explore one of digital art's most powerful tools: layers.

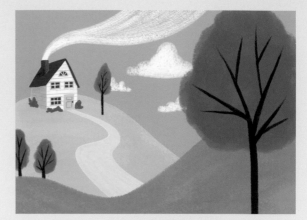

What Are Layers?

Layers are an essential function of making art digitally. Using layers, you can separate parts of your artwork so that you can manipulate them independently of each other.

Imagine layers as sheets of glass stacked on top of each other. In the example here, you can see that the trees, hills, house, and clouds are all on separate layers, but when stacked together, they form a cohesive illustration. You can change something on one layer without worrying about interfering with any of the other layers.

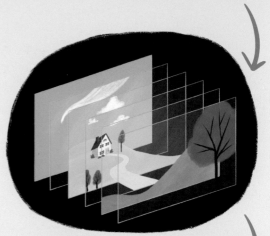

You can use layers to:

- Block or overlap other parts of your drawing
- Apply special effects and fine-tune with adjustments
- Easily duplicate elements
- Reposition elements around the canvas
- Move elements to the background or foreground
- Mask or hide parts of your drawing
- Erase part of an image
- Enable blend modes
- Toggle visibility

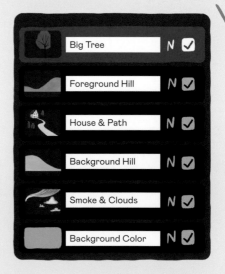

Non-Destructive Workflow

Using layers supports a non-destructive drawing workflow. This simply means that you are creating in a way that allows your work to be editable and reversible, making it easy to experiment. By making your art non-destructively, you never have to 'commit' to anything you do, because you can always go back and reverse or modify what you've done. If you've ever stressed about erasing or painting over something, you probably understand what I mean. After you've worked with layers a bit more, you'll realize how powerful they can be.

Let's look at how I used layers to draw this Monstera leaf. Here is a representation of the Layers panel in Procreate. Content on layers at the top of the list will appear in front of what's on layers at the bottom. The bottom-most layer is always the Background Color layer. By default, it is white, but you can tap through to set it to any solid color.

You can see in the Layers panel that I used one layer to draw the shape of the leaf, a second layer to draw the line details, and a third layer to add some shading. I also utilized Clipping Masks and a blend mode, which you'll learn more about later in this chapter.

NOTE: Layers will give you massive control in the creation process.

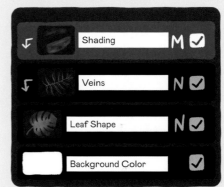

Layers panel

Project: Learn Layers with Leaves

Layers are easier to understand when you see them in action.
Let's learn about layers while making a fun botanical composition.

Draw a Leaf Shape

1. Using the Studio Pen brush (Inking set), draw a long line and add some leafy shapes along either side. Tap into the Layers panel (it's the two overlapping squares on the upper right). You'll see the leaf you just drew labeled as Layer 1. You should also notice the selected layer is highlighted in blue.

Duplicate the leaf: In the Layers panel, swipe to the right with one finger over Layer 1 and tap 'Duplicate'. You'll see in the Layers panel that you now have two copies of that leaf shape.

Alter the New Layer

2. Reposition this new layer to the side using the Select and Transform tools (pages 18–19). You can change the color of this copy in the Adjustments menu (wrench icon). Select the Hue, Saturation, Brightness option and move the sliders around to make the leaves darker and more saturated.

Draw a Blue Leaf on a New Layer

3. Go back to the Layers panel and tap the '+' icon to add a new layer above the other two. Draw a long, blue blobby shape.

Erase Parts of the Leaf

4. Let's erase parts of this blob to make it look more like a leaf. Because this shape is on its own layer, we can erase it without affecting the other sets of leaves. Tap the Eraser icon and select the same Studio Pen brush, then erase a few round shapes from the edges. Next, use a darker blue to add some stem and vein details to the center of the leaf.

COLOR NOTE:
Are leaves really blue? Don't be afraid to think outside the box with color. You'll learn more about working with color in Chapter 4.

Draw a Yellow Leaf

5. This would look better with a leaf behind all the others. Create a new layer, then draw a leaf shape using a warm yellow.

Reordering Layers

6. You can move layers to the foreground or background of your artwork by rearranging them in the Layers panel. Tap, hold, then drag this layer to the end of the layers list.

Add Some Berry Accents

7. Add a new layer beneath all the leaves and draw a few trios of orange dots. Create another layer under the dots layer and draw in some brown stems.

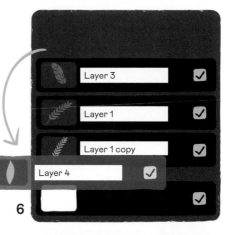

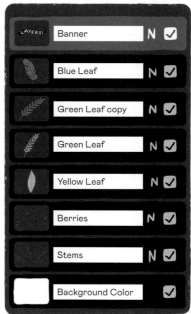

Here's the full layer breakdown for this botanical piece

Finishing Touches

8. You can go back to each layer and add additional details to the different leaves. Finally, create one more layer to add a cute banner at the bottom to celebrate all you have just learned about using layers.

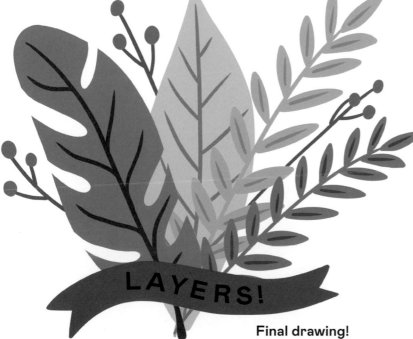

Final drawing!

Alpha Lock & Masks

Digital art offers incredibly useful tools that give you greater control over your work and make the whole process much easier. Alpha Lock and Masks allow you to draw or paint within a determined shape as well as hide or conceal parts of your work. If you were painting, you might use masking tape or masking fluid to control where paint can go. Alpha Lock, Clipping Masks, and Layer Masks fill a similar role in digital art, and each provides this control in a different way.

Alpha Lock

Alpha Lock allows you to control where you can and can't draw. When you turn on Alpha Lock, you are 'locking' the shapes on that layer, allowing you to only draw within those shapes. With Alpha Lock enabled, all empty pixels are effectively inactive, meaning you can only make changes to the pixels you've already drawn on. Alpha Lock is useful for adding texture to shapes of flat color, adding precise details, and other minor changes.

In Procreate, you can enable Alpha Lock from the layer options menu, or by swiping right on a layer with two fingers. The Layers thumbnail shows a checkerboard pattern when Alpha Lock is on.

Let's say you wanted to add some texture or add more color to the original leaf shape. It's not practical to do so, since the leaf and veins are on the same layer. Fortunately, there is another tool that makes this possible. On the next page, we'll look at Clipping Masks.

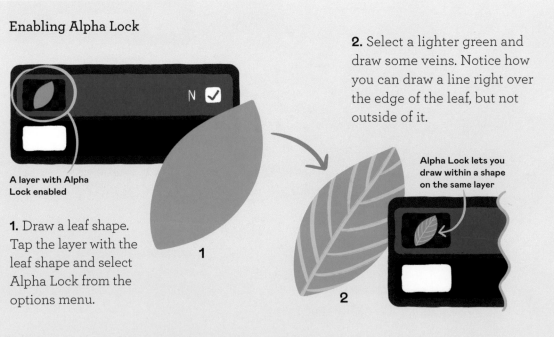

Enabling Alpha Lock

A layer with Alpha Lock enabled

1. Draw a leaf shape. Tap the layer with the leaf shape and select Alpha Lock from the options menu.

2. Select a lighter green and draw some veins. Notice how you can draw a line right over the edge of the leaf, but not outside of it.

Alpha Lock lets you draw within a shape on the same layer

Clipping Masks

Much like Alpha Lock, Clipping Masks allow you to draw within a shape, but what you draw is on a separate layer. The Clipping Mask layer uses the contents of the layer directly beneath it (the 'parent' layer) as the mask. Only the contents of the Clipping Mask layer that are within the shapes on the parent layer can be seen—the rest is hidden.

1. Draw a leaf shape, then add a new layer directly above the leaf-shape layer. Open the Layer Options menu and choose Clipping

Mask. The new layer will indent and display a down-pointing arrow. This arrow indicates that this layer is 'clipped' to the layer below.
2. Draw some leaf veins on the Clipping Mask layer.
3. Next, tap back over to the leaf layer and add some coloring to the center of the leaf with a soft brush. Notice how the veins are unaffected.
4. You can also enable Alpha Lock on the leaf layer to add some all-over texture.
5. You can even erase parts of the leaf layer to change the shape of the mask.

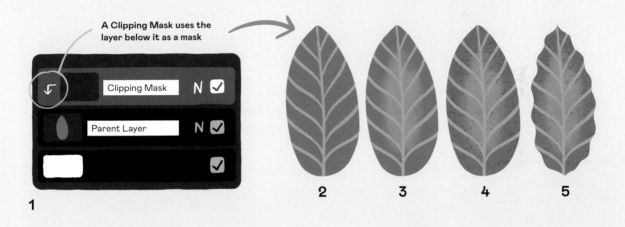

A Clipping Mask uses the layer below it as a mask

1 **2** **3** **4** **5**

Because Clipping Masks utilize a separate layer, you can manipulate each one independently, helping you utilize a non-destructive workflow (page 49). You can use adjustments, set a blend mode (page 55), change the opacity, change colors, and add filters (and more) to either layer without affecting the other. I use Clipping Masks whenever possible while adding details to my work. You can even stack multiple Clipping Mask layers, and they will all be clipped to the same parent layer.

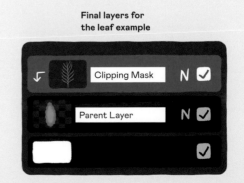

Final layers for the leaf example

Layer Masks

A Layer Mask is a fully customizable way to hide or reveal the contents of a layer. This type of mask is completely customizable and editable—you can create a mask in any shape or opacity, making it extremely versatile.

Layer Masks are a great way to non-destructively 'erase' parts of your art by hiding them with a mask.

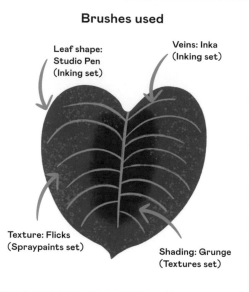

Brushes used

Leaf shape: Studio Pen (Inking set)

Veins: Inka (Inking set)

Texture: Flicks (Spraypaints set)

Shading: Grunge (Textures set)

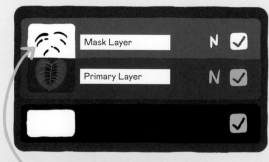

1. Draw a new leaf shape and add some texture and details. From the Layer Options menu, choose Mask. Attached to the top of the leaf layer (the primary layer) is a white mask.

2. Tap the mask layer and paint in black, white, or shades of gray. Paint with black to hide the contents of the primary layer and use white to reveal them. If you paint in gray on the mask, you'll get semi-transparent visibility of the primary layer.

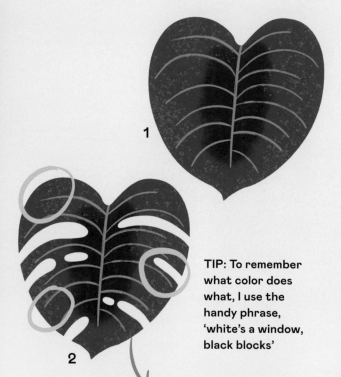

TIP: To remember what color does what, I use the handy phrase, 'white's a window, black blocks'

Mask Layer	N	☑
Primary Layer	N	☑
		☑

The black areas on the mask 'block' (hide) those same areas on the primary layer

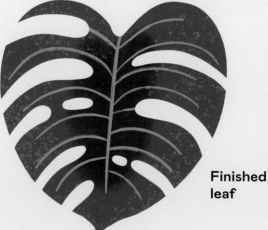

Finished leaf

Blend Modes

A layer's blend mode determines how it interacts with the layers below it.

Think of a blend mode layer as a translucent colored film placed over an image. You can see through the film to the image underneath, but the image will appear altered depending on the film's colors and values. A blend mode layer will affect all visible layers beneath it, making it useful for easily adjusting the brightness or color of textured or detailed elements.

There are a lot of available blend modes, each with its own formula that determines how it interacts with the layers below. The most effective way to learn how they work is to experiment.

The four blend modes I use most often are:

Multiply
Multiply has an overall darkening effect and is useful for adding shadows. All light pixels on the blend layer become transparent, and the darker pixels multiply or combine with the base layer.

Screen
Screen is ideal for adding highlights, as it's the opposite of Multiply. All dark pixels become transparent, and the light pixels make the base layer lighter. Overall, it has a brightening effect.

Add
Add is similar to Screen, but the brightening effect is more intense. Add also increases the color intensity of the base layer. This blend mode is useful for creating glow effects.

Overlay
Overlay is great for adding texture to flat areas. It combines the effects of Multiply and Screen. Dark pixels make the base layer darker, and light pixels make the base layer lighter. 50% gray pixels become transparent.

Blend Modes Explained

Blend layer

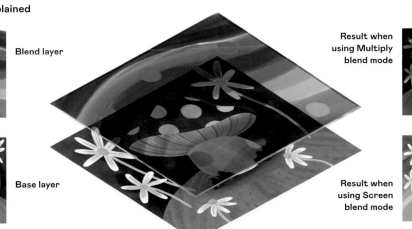

Result when using Multiply blend mode

Base layer

Result when using Screen blend mode

How to Change a Layer's Blend Mode in Procreate

In the Layers panel, tap the letter N next to the visibility checkbox. Scroll to select a blend mode from the list that appears below the layer.

Using Blend Modes for Shading

One of the most practical applications of blend modes is adding shadows and highlights. Clipping Masks make it easy to selectively add shading to particular areas, as demonstrated in this mushroom illustration. Generally, warm colors work well for highlights and cool colors for shadows. However, experiment with the color you use in your blend layer to see what works best for the base color. Additionally, you can layer different values within the blend layer to achieve a graduated lightening or darkening effect.

Multiply for Color Mixing

You can also use blend modes to mix colors. The overlapping shapes in these mushrooms were on separate layers with their blend modes set to Multiply.

Experiment with color palettes by making a trio of overlapping colored circles, each on a separate layer set to Multiply. Adjust the individual colors and see what blended colors you get as a result. In the end, you will have a palette of seven colors that work well together.

Screen for highlights

Multiply for shadows

Result

Overlay to Texturize

The Overlay blend mode allows you to easily add textures to your illustrations. First, I painted some brush strokes in watercolor, scanned the painting, and converted it to grayscale. Then I used it as a Clipping Mask over the mushrooms and set the blend mode to Overlay to achieve this striking result.

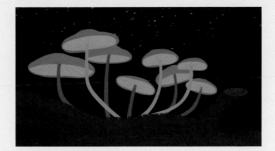

Add Glow Effects

To add a glowing effect to these bioluminescent mushrooms, I duplicated the mushroom caps, blurred them with the Gaussian Blur tool, and set the blend mode to Add. You can duplicate your blend layer to make the effect more intense. I also used an Add Blend Layer to paint in some highlights on the tree bark.

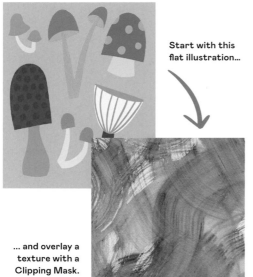

Start with this flat illustration...

... and overlay a texture with a Clipping Mask.

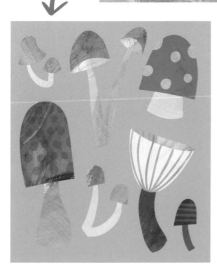

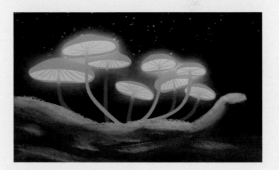

Adjusting your Blend Effects

If the effects of using a blend mode are too intense, you can reduce the opacity of the blend layer. You can also use the Hue, Saturation, Brightness adjustment to decrease saturation or make the blend layer lighter or darker.

There are lots more blend modes, and they all lend themselves to a variety of different effects, so don't be afraid to experiment.

Coloring Workflows

What's the difference between a doodle and a hyper-realistic drawing? Rendering!
Rendering is the use of value and color to depict texture, shading, and details,
transforming a flat shape into an object your brain perceives as real.

There are many ways to take a piece of
digital art from a pencil sketch to fully
rendered. The process and method you utilize
when digitally rendering artwork is called
a coloring workflow. It is also known as a
coloring process, or painting workflow.

Here, I will set out three different coloring
workflows, but there are many more, and
as you progress in skill as a digital artist,
you may experiment with different coloring
workflows or combine methods from multiple
ones. The workflow you choose might also
be influenced by the visual style you hope to
achieve. In the end, a workflow is as personal
to an artist as the work they create, so see
what works best for you.

Layered + Locked

1. In this workflow, you draw the different
shapes of each element in the piece in flat
color. Shapes of differing colors are placed on
their own layers (like you did in the project
on page 50). Once the shapes are defined and
finalized, these shapes are 'locked' and used
to control the addition of texture and details.
This can be achieved through the use of
Alpha Lock, Clipping Masks, or Layer Masks,
along with blend modes for shading. Try the
Potted Snake Plant project on pages 60–63 to
explore this workflow.

1

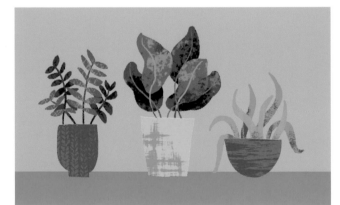

Colorized Line Art

2. In this workflow, the artist draws the outlines of the subject before adding color, texture, and shading within the lines. In this style, the line art is the star of the show. A comic book is an excellent example of colorized line art. Try this workflow with the Colorized Line Art Cacti project on pages 64–65.

2

3

Painterly

3. This workflow is most like working with physical paints. The artist layers on strokes to create color variations and shading, usually on the same layer. With the painterly method, the artist works from broad areas of color to fine details. The shapes are more fluid and changing, and often very expressive. In this workflow, you must be cautious of working from back to front to avoid painting over anything important. Practice a painterly workflow by completing the Painterly Trees & Grass project on pages 66–67.

Project: **Potted Snake Plant**

Put everything you've just learned into practice to draw a potted plant. Create a full-color illustration from rough sketch to coloring and shading while using layers, Alpha Lock, Clipping Masks, and blend modes.

Part 1: **Sketch**

Lay It Out

1. Start with a very light sketch to define the proportions and placement of the elements of the potted plant. Using the 6B Pencil (Sketching set), draw a trapezoid for the pot and a line for each leaf. Be sure to vary the height of your leaves.

Create a Rough Sketch

2. Using heavier pressure, sketch a tapered cylinder to make the 3D form of the pot. Draw an oblong tapered shape over each of the vertical lines to define the leaves.

Make a Refined Sketch

3. Turn down the opacity of your rough sketch layer and create a new layer above it. Trace over your sketch with more organic curves and details. This is where you'll start to figure out what elements overlap and what you'll need to place on separate layers. In this drawing, I see that I'll need to make three layers of leaves.

Part 2: Color Main Shapes

Draw the Pot in Layers

1. Outside of the pot: First, turn off the visibility of your rough sketch. Next, reduce the opacity of your refined sketch, then create a new layer below your refined sketch layer. Using the Studio Pen brush (Inking set), outline the pot shape and fill it with Color Drop.

 1a. Inside of the pot: Create a layer above the orange pot to color the inside of the pot. Make this layer a Clipping Mask. Draw the top part of the pot in a darker, more saturated orange. Create another layer above that, make it a Clipping Mask, and draw the lip of the pot in a lighter orange.

Create the Leaf Shapes

2. Create a layer above the three pot layers to start drawing the leaves. Select a rich, dark green and draw in the back-most set of leaves. Create a new layer above the previous and draw the middle set of leaves. Finally, make one more layer for small leaves in the front.

Fill the Pot with Dirt

3. Create a layer above the inside pot and pot lip layers. It should automatically become a Clipping Mask because it's stacked between other layers that are Clipping Masks. Use the 6B Compressed brush (Charcoals set) to draw in some dirt texture. Use a couple of shades of brown to make it look more realistic. Use a very dark brown near the base of the leaves.

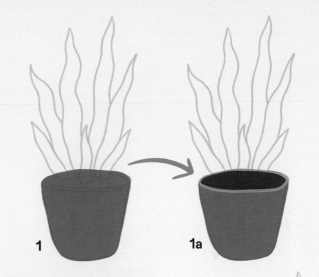

1 **1a**

Refined Sketch	N	☑
Pot Lip	N	☑
Inside Pot	N	☑
Pot Shape	N	☑
Rough Sketch	N	☑
		☑

2

TIP: If it gets hard to see what you're drawing, turn off the visibility of the back leaves as you draw these shapes.

Part 3: Details & Shading

Add Variegation to the Leaves

1. Enable Alpha Lock on all three leaf layers. Select a lighter, warmer green and Old Beach (Artistic set) as your brush. Using a vertical scribbling motion, draw in some irregular stripes on the leaves. Repeat this for each layer of leaves. Next, select a bright yellow-green and use the same brush to paint a stripe along the side of each leaf. At this point, you can turn off the visibility of your sketch layer.

Add Shadows to the Leaves

2. This is looking great, but all the leaves kind of blend together. Let's add some shadows to give them a little separation. To do this, you're going to use Clipping Masks and a blend mode.

Starting with the back-most layer of leaves, add a new layer just above it. Make this layer a Clipping Mask and set the blend mode to Multiply.

Select the Compressed 6B brush. You may need to experiment with what color looks best to make the shadows, but I used a medium-value muted green here. Remember, the darker the color, the faster and more intensely it darkens the layer below, while light colors have a less intense darkening effect.

Use Clipping Masks to add shadows to each of the layers of leaves. On the front-most layer of leaves, add some shadows near the base of the leaves.

Decorate & Shade the Pot

3. Enable Alpha Lock on the orange pot layer. Then, using yellow and the Old Beach brush at a large size, draw some stripes. Just like you did with the leaves, create a layer above the orange pot set as a Clipping Mask. Use the Compressed 6B to shade the side of the pot. Add a few light strokes in a darker color at the very edge of the pot. I've shown you the two colors I used on this piece, but experiment with brightness, hue, and saturation to find the colors that work best for your piece.

Layer in More Dirt

4. Finally, add one more layer above all the other layers. Select a dark brown and, using Compressed 6B, paint in a little more dirt over the base of the leaves. Your snake plant is complete.

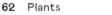

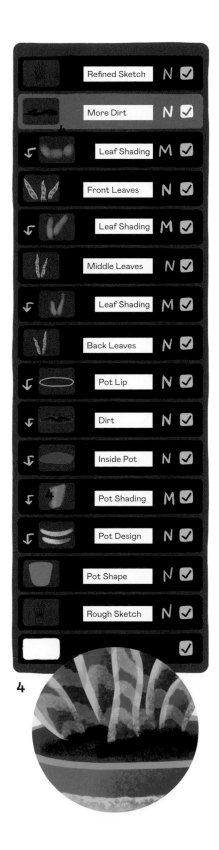

	Refined Sketch	N	✓
	More Dirt	N	✓
	Leaf Shading	M	✓
	Front Leaves	N	✓
	Leaf Shading	M	✓
	Middle Leaves	N	✓
	Leaf Shading	M	✓
	Back Leaves	N	✓
	Pot Lip	N	✓
	Dirt	N	✓
	Inside Pot	N	✓
	Pot Shading	M	✓
	Pot Design	N	✓
	Pot Shape	N	✓
	Rough Sketch	N	✓
			✓

4

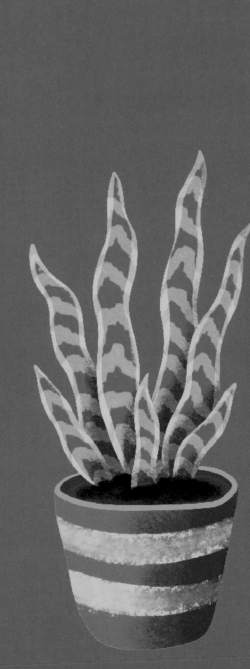

Your finished snake plant in a pot!

Project: Colorized Line Art Cacti

Creating colorized line art is easy thanks to Procreate's Reference layer feature. Learn how while drawing a cluster of cacti.

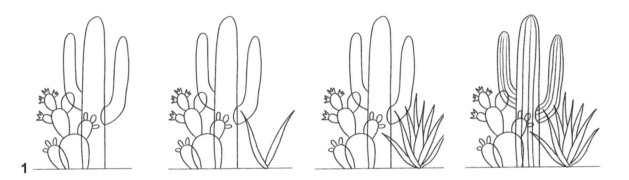

1

Create a Sketch

1. Sketch out your design, one plant at a time. Don't worry if things are overlapping in this sketch.

Use Layers for Cleaner Line Art

2. On a new layer, trace over your sketch to create the outlines of one element of your illustration. For this example, I am using the

Monoline brush (Calligraphy set). It's much easier to draw a continuous line than one that starts and stops, like down the center stalk of this cactus. You can place touching or overlapping elements on separate layers while creating your line art. This allows you to go back and easily erase unnecessary lines without affecting lines on the other layer. Using this method will produce much cleaner line art.

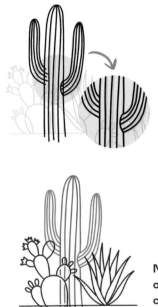

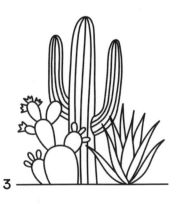

2

NOTE: It's helpful to reduce the opacity of background elements so you can more clearly see which lines to erase.

Clean Up & Combine Layers

3. Once you've cleaned up any unnecessary lines, you need to combine your line art into a single layer. One way to do this is by merging the layers together, but Procreate's 'Copy All' function is more non-destructive. Turn off the visibility of all other layers, including the background, so only your line art layers are visible. Swipe down with three fingers to open the Copy/Paste menu. Select 'Copy All.' Repeat the gesture and select 'Paste.' All your line layers are now combined into one while retaining your separated layers. Turn the background layer back on.

3

Turn on the Reference Feature

4. Hide all layers except the merged line art layer. Tap the layer to open the Layer Options menu and tap 'Reference.' Create a new layer below the line art layer. With Reference turned on, you can now Color Drop within the lines for your Reference layer, but on another layer.

Color in the Cactus

5. Fill in the largest cactus with color using Color Drop.

Color Plants on Separate Layers

6. Create a new layer to color in the other cactus and a third layer for the final plant. Separating the different plants or colors on to their own layers will make it easier to add texture and details later.

Add Texture & Details

7. Because you used the Reference layer feature, the different cactus plants are on separate layers, so you can use Alpha Lock or a Clipping Mask to add texture to these flat colors. On this piece, I used Dry Brush (Painting set) for the texture, Chalk (Calligraphy set) for the lines, and Monoline for the prickly pear spines.

TIP: To fill in multiple shapes with the same color, after using Color Drop, tap 'Continue Filling' at the top of the canvas. Now you can continue filling shapes with color by tapping them.

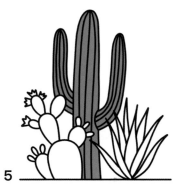

5 _____

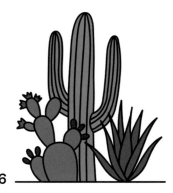

6 _____

7

Your finished cacti!

Project: Painterly Trees & Grass

Familiarize yourself with a painterly workflow by learning to draw trees and grass. For this example, I am using the Blackburn brush (Drawing set). Experiment with pressure while using Blackburn to bring out the brush's bristly, dry texture.

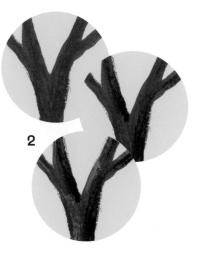

Paint the Trunk & Branches
1. Using this brush's pressure sensitivity, make a tall, tapered shape with irregular lines branching off them.

Create the Bark Texture
2. Lightly brush some bark texture on the trunk and branches in a slightly darker brown. Use dark brown to create shadows on one side and light brown to create highlights on the other side.

Shape the Tree Foliage
3. Create a new layer, then select a dark green. Using a large brush size, paint the foliage shape with small dabs and erratic strokes. Leave some holes so you can see the background.

4. Add smaller details to the edges by reducing the brush size.

Color Tip
When choosing shades of green, make the darker greens cooler and more saturated. Lighter greens should be warmer.

Create Dimension By Layering Color

5. Using a darker green, paint a few clusters of tiny strokes, then, with a larger brush size, dab some broad strokes using a medium green. Reduce the brush size and add a few smaller strokes around those medium green spots to suggest individual leaves.

Layer on a Lighter Hue

6. Repeat the previous step with a lighter green, making the strokes smaller and sparser.

Add Spotty Highlights

7. Finally, create a few small highlights with a pale green color. The highlights should be on the same side as the light source.

Painting Grass

1. Start with light green first. Use a large brush size and make lots of quick upward strokes. Reduce the brush size and add a few small strokes of the lightest color to highlight individual blades of grass.

2. Paint in a darker shade of green using both broad and thin strokes. Be sure to leave the previous color visible at the top.

3. Repeat with the darkest green.

4. Using two of the lighter colors, layer some blades of grass over the darkest green.

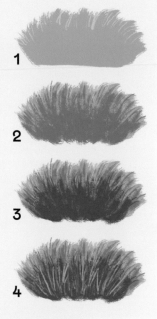

5

Darker Green Medium Green

Lighter Green

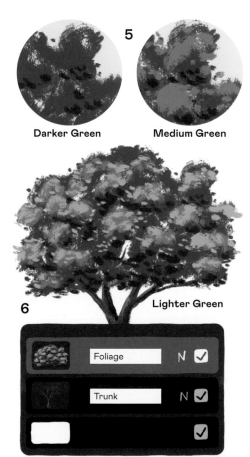

6

Foliage	N ✔
Trunk	N ✔
	✔

7

The final painterly tree & grass!

4
Flowers
Color & Style

Flowers are everywhere, bringing color, life, and whimsy to our lives, just as artists do with their unique visions and creations. While you'll learn to draw flowers in this chapter, you'll also be learning how to bring your signature voice and style to your creations. You'll learn the principles of color theory and how to harness hue, saturation, and value to create aesthetically pleasing palettes. You'll also learn that 'finding your style' as an artist is the result of a lot of research, practice, and play, which might look something like this:

'I don't know how to draw a flower.'

You take the initiative to learn something new and practice it...

'OK, I know how to draw a flower.'

. . . then you start experimenting . . .

'I could draw a flower this way, or this way, or that way.'

. . . until you find something that feels right . . .

'It feels natural to draw a flower this way.'

. . . tweaking your process, until . . .

'This way of drawing a flower feels like me.'

. . . you find your style.

Let's get started!

Digital Color Theory

We've already been working with color in this book, but let's take some time to learn a bit about color theory—a set of guidelines and principles on combining colors in an aesthetically pleasing way. Studying color theory gives you a deeper understanding of how colors interact, and how subtle changes to hue, saturation, and value can significantly impact your work. Of course, there's much more to color theory than can fit into a couple of pages, but it is worth getting familiar with the basics and how they relate to digital art.

Three Properties of Color

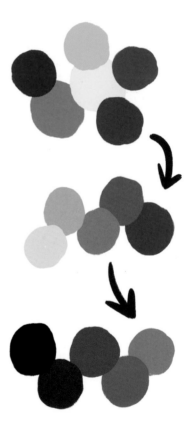

Hue—What 'Color' Is It?

A color's hue refers to whether it is red, blue, green, yellow, etc. It's the word you think of first when imagining a color. Hue is measured in degrees from 0° to 360°.

Saturation—How Vibrant Is It?

Saturation refers to the intensity of the hue. Saturation of 0% is no color, while 100% means fully saturated pure color.

Brightness—How Light or Dark Is It?

Brightness represents value—how light or dark the color is. In this context, 0% brightness is black and 100% is white.

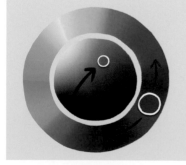

Procreate's Color Picker

These three properties define all colors in digital art. When selecting colors in Disc view on Procreate's Color Picker, you first choose a hue using the outer ring, then adjust the color's saturation and brightness using the inner disc.

Warm & Cool Colors

All colors can be described as warm or cool. Warm colors are on the red/orange/yellow side of the color wheel, and cool colors are on the purple/blue/green side. Additionally, a single hue can be warm or cool. For example, you can make a green warmer by shifting the hue closer to yellow or cooler by shifting toward blue.

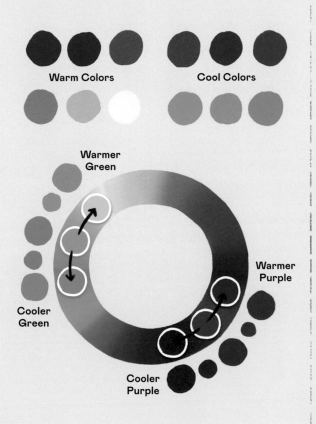

Warm Colors

Cool Colors

Warmer Green

Cooler Green

Warmer Purple

Cooler Purple

Editing Colors in Procreate

Fine-tune or experiment with colors using the Hue, Saturation, Brightness adjustment, found in the Adjustments menu (magic wand icon). Use the sliders to alter the hue, saturation level, or value of the colors in a particular layer or selection.

Hue & Saturation Shifts in Shading

There's a phrase in art: 'Change the value, shift the hue.' It should come as no surprise that light is warm and shadows are cool. As you darken your value to paint in shadows, make the hue cooler. Shift the saturation, too—shadows are often more vivid than their lighter counterparts. This rule doesn't apply in every case, but generally, shadows are darker, cooler, and more saturated. Highlights are lighter, warmer, and less saturated.

Take note of the differences in hues used on these two flowers. When coloring the flower on the left, I only changed the color's brightness, not the hue. The result is a bit muddy and dull. For the flower on the right, I shifted the hue cooler or warmer for the darker and lighter spots and increased saturation. As you can see, the flower on the right looks more vibrant.

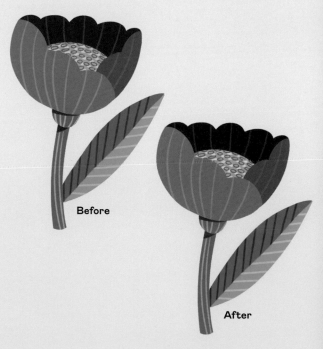

Before

After

Color & Value

Value refers to the overall lightness or darkness of a color. You can change the value of a color by adding black or white to it, but did you know that certain hues can have drastically different values, even without adding anything?

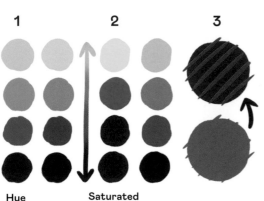

Hue Saturated
 color, no black

1. Column 1 shows a single green hue in four different values.
2. Column 2 shows four fully saturated colors with no black added. Notice how much lighter in value yellow is compared to blue when fully desaturated. Understanding the value of color is extremely important when pairing colors next to each other to ensure there's enough contrast.
3. When placed next to each other, contrasting colors of similar values can 'vibrate', appearing unsettling to the viewer, so stay aware of your color's value.

When we remove the color, we can see how this bouquet has a range of values from light to dark.

Shade, Tint & Tone

It's important to use a range of values and vibrancies when working with colors —using only bright, fully saturated colors can sometimes look jarring. Instead, color your art with shades, tints, and tones to add variety.

1. A shade is made by adding black to a color, creating a variation that is deep, saturated, and intense.
2. A tint is made by adding white to a color, making it lighter and paler.
3. A tone is somewhere in between—the result of adding both black and white (neutral gray) to a color. Tones are more mellow and muted than their fully saturated counterparts.

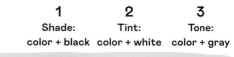

1	2	3
Shade:	Tint:	Tone:
color + black	color + white	color + gray

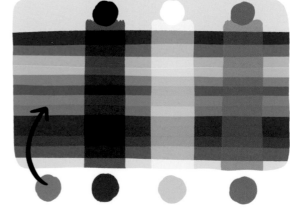

Saturated Desaturated

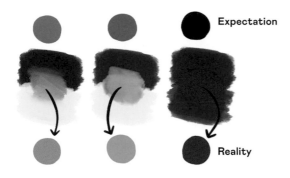

Expectation

Reality

Smudging ≠ Color Mixing

In digital art, you don't 'mix' paint as you do with physical media. Using the Smudge tool is excellent for softening transitions between colors, but don't be surprised if smudging colors together produces muddy-looking results. You are better off selecting the color you desire and brushing it in than trying to mix to get it. The big exception here is with blend modes. I often use the Multiply blend mode to mix colors. See pages 55–57 for more on blend modes. For the best results when mixing colors using blend modes, you need to understand something surprising about primary colors.

Rethink Primary Colors

As shown on page 56, you can use the multiply blend mode to overlay colors, blending them to create new hues. You were probably taught in kindergarten that the primary colors are red, yellow, and blue. As you can see in the diagrams on the right, those three hues don't produce the results you might expect. Stick to cyan, yellow, and magenta for color mixing and you'll get much more vibrant results! Notice how the colors blend in this flower illustration.

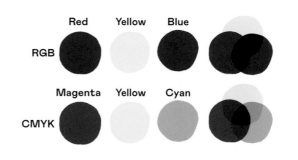

Red Yellow Blue

RGB

Magenta Yellow Cyan

CMYK

Working with Color Palettes

How do you pick colors that look good together? How do you know how many colors to use in a given artwork? In digital art, there are nearly 17 million colors to choose from, so narrowing these down to just a handful is incredibly useful. Working with a color palette—a limited selection of colors—simplifies the coloring process and creates a harmonious and unified look in your art.

Color Harmonies

While deciding which colors look good together, it's helpful to employ established color harmonies, which represent relationships between colors on the color wheel. You can see in the examples below that the palettes I created from these harmonies contain colors with varying saturations and brightness levels.

TIP: Tap over to the 'Harmony' mode in Procreate's Color Picker to easily create color harmonies.

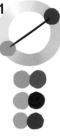
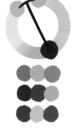

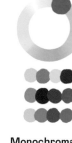

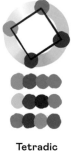

1

Complementary Split-Complementary Analogous Monochromatic Triadic Tetradic

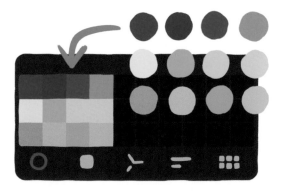

Making a Color Palette

Once you've got a palette you're excited about, you can save it using Procreate's Palette feature. Tap over the 'Palettes' mode in the Color Picker and tap the '+' to create a new palette. Tap the squares to save each color. Now you can easily recall colors as you work on a piece.

A Go-to Color Palette

As you progress in your artistic skill, you may find that you have a go-to color palette that you use again and again in your work.

I love bright, saturated colors, so I often use some form of this palette, especially teal, blue, and pink.

Making Palettes from Photos

One of my favorite ways to make a color palette is using photography. Whenever I come across a photo with colors that sing to me, I import it into Procreate. Using the Eyedropper, I sample colors from the image and paint swatches on my canvas. A palette can also be generated automatically by importing a photo directly into the Palettes tab in Procreate, but I like to do this manually because it lets me tweak the colors to create a pleasing palette.

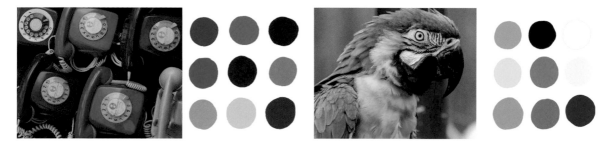

Here are a few examples of palettes made from photos

How to Use a Color Palette

Working with a limited color palette can help you make art that feels more sophisticated and cohesive—and can lead to using colors in unexpected ways. When working with a limited color palette, emphasize just one or two colors and incorporate a range of values. Make a color hierarchy plan to decide how to distribute colors in a piece.

First, decide which colors in the palette will be dominant. I started with pink and green (complementary colors!). Draw large swatches of those colors, then add smaller swatches of the other colors. Don't go overboard: using fewer colors can help a piece look more unified.

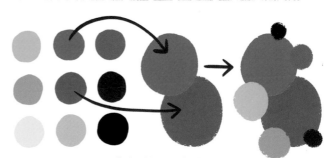

Color Hierarchy Plan

In this palette, there are only three hues: three pink values, three green values, and a muted orange.

How to Draw Flowers

Drawing flowers is a great way to add beauty to your digital sketchbook, practice your drawing skills, and explore your creativity. Flowers may seem complicated, but you can create intricate blooms out of simple shapes.

Petal Practice

To draw flowers, you'll first need to learn how to manipulate an individual petal. Within a single flower, you may need to depict a petal from the front, back, top, bottom, or side, with its ends turned up or down, curled, curved, or flat. Practice drawing a couple of different petal shapes from multiple angles and positions.

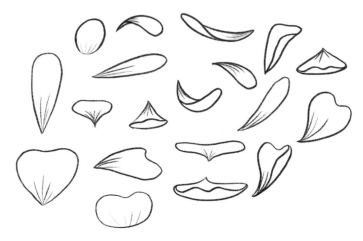

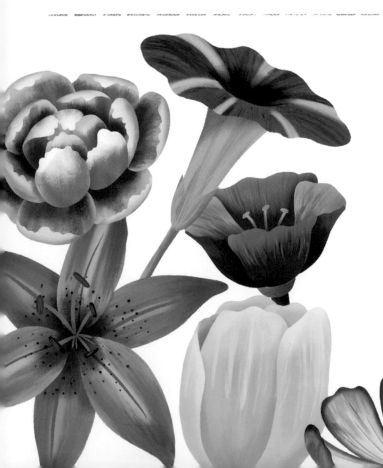

Step-By-Step Guide to Drawing Flowers

Once you've mastered petals, move on to drawing the entire flower.

1. Start with a basic shape, just as you did when drawing objects. Flowers are often shaped like bowls or cups, so start there.
2. Then divide the shape by the number of flower petals.
3. Next, draw simple petal shapes over these sections.
4, 5. Finally, refine the sketch by drawing over your construction lines with organic lines and curves.

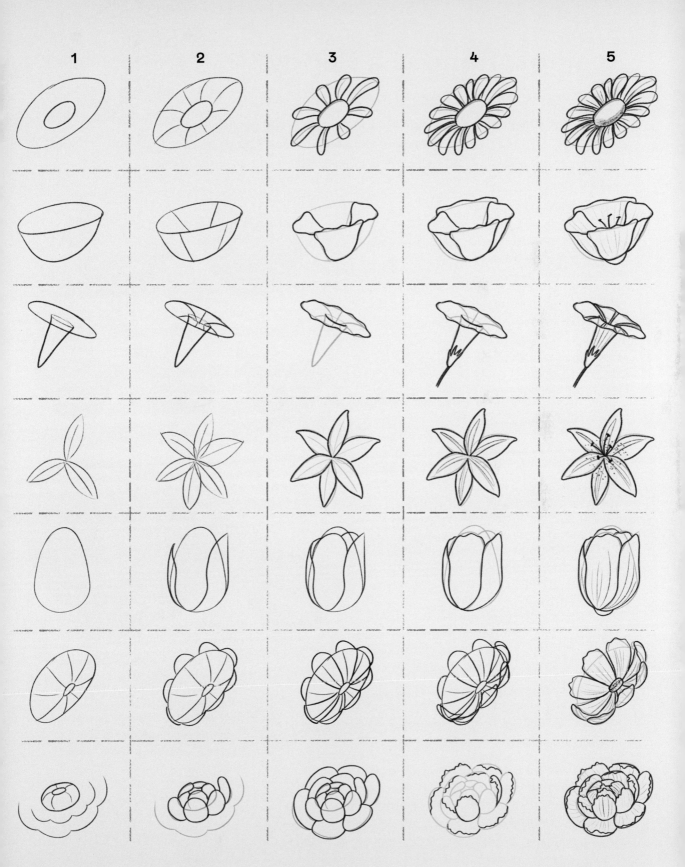

Project: Render a Poppy

This project will guide you through coloring and finishing your flower sketches using layers, Alpha Lock, and the Smudge tool. Along the way, you'll learn what to do if your artwork is looking flat.

Draw the Petals in Layers

1. Use the steps on the previous page to sketch a poppy, then you're ready to render. Start by drawing the shape of each petal, separating anything that overlaps something else on to separate layers. I used the Dry Ink brush (Inking set) to draw these shapes.

Create a Gradient

2. Enable Alpha Lock on a petal layer. Then select a brush with soft edges, such as Soft Brush (Airbrushing set), and paint color variations on the petal. For this petal, brush on lighter yellow-orange at the top and a darker, more saturated reddish-orange at the bottom.

Make Directional Texture

3. Next, use the Smudge tool to create directional texture. Select a bristly brush to use with the Smudge tool, such as Dry Brush (Painting set). Make several smudging strokes in an up-and-down motion, following the contours of the petal. The light values will spread into the dark areas and vice versa, creating a lovely petal texture.

4. Repeat steps 2 and 3 for the other petal layers.

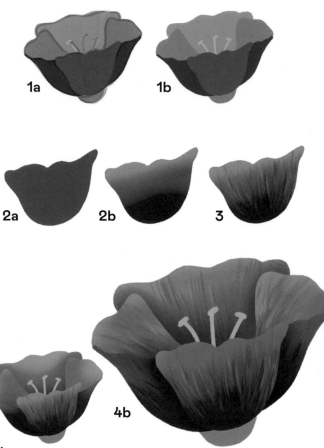

Contrast

Contrast is the juxtaposition of two opposing elements, emphasizing the differences in colors, values, shapes, textures, symbolism, and beyond. The bigger the differences, the greater the contrast. Dark and light, big and small, rough and smooth, simple and complex: contrast is a key art principle that can dramatically improve your artwork.

Overall, I'd say this flower looks a little flat. When I look at something I've drawn and feel that something is lacking, my first instinct is usually to add more contrast.

Looking back at the flower, all the values in the middle are very similar. Everything is blending together, and nothing pops. So, let's make some adjustments.

Making Adjustments

There are several ways to edit color or value in your digital artwork. Find these in the Adjustments menu (magic wand icon). These adjustments will modify everything on the selected layer, or within whatever selection you have made.

Hue, Saturation, Brightness Adjustment

With the HSB adjustment, you can alter the hue, saturation, or brightness level of your layer or selection. This adjustment is a great way to experiment with hues and make value adjustments to solid colors.

You can see that increasing the brightness makes everything brighter, including the bottom part of the petal. Now it looks a bit washed out. So let's alter these colors a different way.

HSB Adjustment Panel

| Hue | 50% | | Saturation | 50% | | Brightness | 60% |

With HSB adjustment

Curves Adjustment

With the Curves adjustment, you can individually fine-tune the different values within your selection. In Procreate, the Curves adjustment is the best tool for increasing contrast.

Move the blue nodes to adjust light and dark values. Alternatively, you can tap and drag anywhere on the line to add a new node, causing the line to curve.

A curve pattern like the one to the right would increase contrast—it pushes the dark values darker and the light values lighter.

Lighter — Darker

Modify Dark Values Modify Midtones Modify Light Values

Contrast-Boosting Curve Pattern

With Curves Adjustment

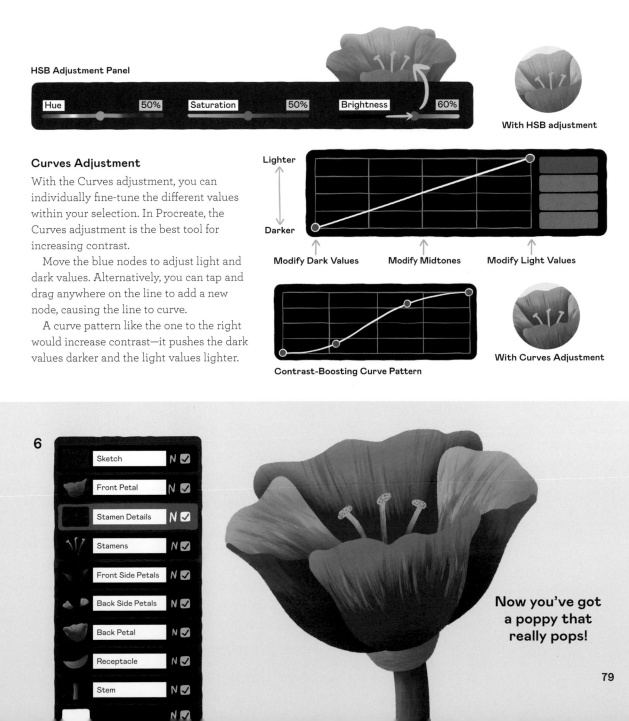

6

Sketch	N ☑
Front Petal	N ☑
Stamen Details	N ☑
Stamens	N ☑
Front Side Petals	N ☑
Back Side Petals	N ☑
Back Petal	N ☑
Receptacle	N ☑
Stem	N ☑
	N ☑

Now you've got a poppy that really pops!

What is Stylization?

Stylization is the act of taking creative liberties when you draw something, depicting it in a way that is not realistic. Each artist has their own approach to how they stylize something. This is what is often referred to as an artist's style—a recognizable aesthetic that can be used to identify them among other artists. Of course, you need to get to grips with a skill before you can put your own flair on it, so don't feel bad if you haven't found your 'style' yet. You're still learning!

You can develop your style through experimentation and consistent practice. An excellent place to start is by looking at your favorite artists and seeing how they have stylized things differently than others. Take inspiration from them, but don't try to copy them exactly (plagiarism is never OK). You can also look back at the work you've already created and identify what you like and dislike about it. Sometimes it's helpful to think of yourself as an art critic, evaluating your own creations and making notes about what you'd do differently in future pieces. This will help you get more in touch with your creative instincts, leading you down the path toward establishing your signature style.

Here are three exercises to improve your stylization skills.

How Low Can You Go?
1. Choose a subject—in my example, an anemone flower. Draw it with the least amount of detail possible. Reduce the number of colors used. Smooth out complex shapes. Eliminate lines. Does it still 'read' as that particular flower? Does it resemble a flower at all? If not, what details can you add back?

TIP: The key to stylization is using your personal preferences to strike a balance between realism and the bare minimum.

1

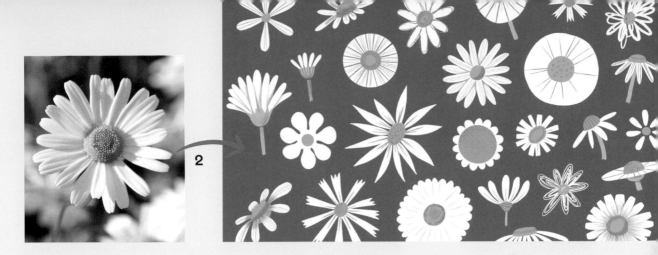

Style Brain Dump

2. Get some references, such as photographs or real daisies, and draw the flower in as many ways as you can. No idea is a bad idea! How far can you push the subject and have it still be recognizable? Try these ideas:

- Reduce it down to its simplest shapes
- Play with ratios and proportion
- Be loose and expressive or precise and symmetrical
- Make rounded corners more angular or vice versa
- Play with patterns within shapes
- Experiment with different brushes
- Remove details (or add extra details)
- Use line work in the place of shading
- Draw your subject from another angle

Aim to fill your entire canvas. Which versions are your favorites?

Draw It Again (and Again)

3. Start with a reference photo of your subject. In this example, I'm using a protea flower. Begin by drawing the flower as you see it, observing and depicting as many details as possible.

When you've finished, put away the photo. Then draw the flower again, this time using the previous drawing as your reference.

Next, draw your previous drawing. I did this a total of four times to achieve this stylized protea.

Each time you draw it, you have less information to work from, allowing you to incorporate specific details you noticed in the previous drawing. It's not just a matter of simplifying the subject each time, but being selective about which details to include, and illustrating them in a creative way.

81

Project: Vase of Flowers

Once you've got some practice drawing flowers under your belt, worked out a visual style, and experimented with color palettes, it's time to put it all together to illustrate a full floral composition: a vase of flowers.

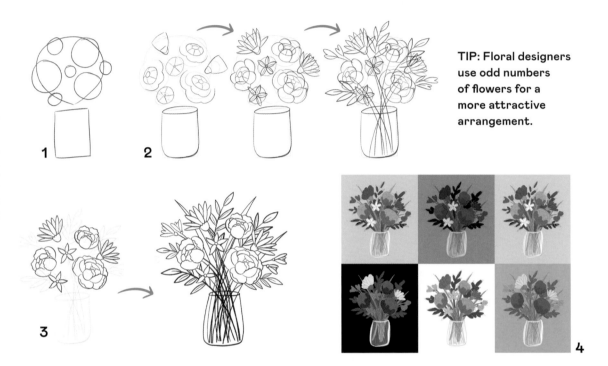

TIP: Floral designers use odd numbers of flowers for a more attractive arrangement.

Establish the Layout

1. Decide the proportions of your illustration and lay out the position of the flowers by using simple shapes. Draw a rectangle for the vase and a circular shape for the overall shape of the bouquet. Draw three large circles for the focal flowers and a few more to fill in the rest of the space.

Make a Rough Sketch of All the Elements

2. Reduce the opacity of this basic sketch. On a new layer, sketch the vase's shape as a 3D form and draw construction lines for the flower petals. Sketch the shapes of the flowers, including the petals. Don't worry about adding too much organic detail at this stage. Sketch in some greenery and filler, including sprigs of leaves and smaller flowers.

Create a Refined Sketch

3. Reduce the opacity of the rough sketch and turn off the visibility of the first sketch. Create a new layer to make a refined sketch. Draw the flowers with organic lines and curves, just as you'd like them to appear in the final illustration. Fill in the remaining leaves and stems, as well as the vase, to complete your refined sketch. Turn off the rough sketch layer.

Make a Color Plan

4. Take some time to create a few color studies before you start working on your final rendering. Loosely block in the color of the different elements, using your final sketch as a guide. Use Color Drop or the Hue, Saturation, Brightness adjustment to experiment with various color palettes.

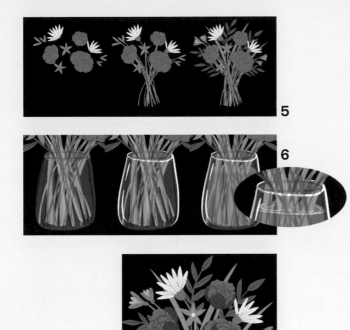

Create Flat Shapes of All Bouquet Elements

5. Set your background color, then reduce the opacity of your sketch. Work with your refined sketch layer as your top layer. Draw the blooms with a simple shape-making brush. Remember to place overlapping flowers on separate layers to make it easier to add details and shading later. Then draw in stems on their own layers. Finally, draw the remaining greenery. In my example, I created separate layers for different shades of green.

Render the Glass Vase

6. Select a blue color and draw an oval for the vase's opening on a layer below all the flower layers. Draw the vase body on top of all the stem layers. Reduce the opacity of those layers to mimic transparent glass. Then, on a new layer, add some highlights for the top rim and edges of the glass vase.

For the water in the vase, create a semi-opaque layer of blue. To sell the glass effect, leave a gap between the edge of the water and the edge of the vase. To make the stems appear to be going into the water, add some ripple lines around the stems, then erase part of the water shape that overlaps the stems, as shown.

Add Line Work, Shading, & Final Details

7. Finally, add some line details to define the petals, leaves, and stems. Be sure to turn off your sketch layer to see how everything is looking. At this point, you can also add additional shading, but I chose a simple, flat style for this illustration. Don't forget to add a drop shadow under the vase to complete the drawing.

Your finished vase of flowers!

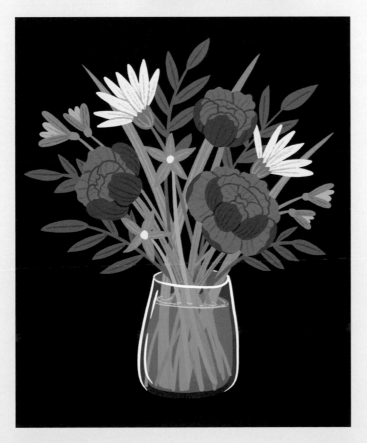

5
Animals
Defining Features

Let's make some animal friends! In this chapter, you'll learn how to analyze and identify the defining characteristics of animals, and you'll discover why drawing animals requires more generalization than absolute accuracy. Plus, you'll see how you can use this method for drawing any subject. You'll also wrap your head around drawing animal heads and get a leg up on drawing animal legs. As you explore what makes different types of animals unique, you'll learn how to exaggerate proportions to emphasize their features. In the final project of this chapter, you'll put all that you've learned into practice to illustrate man's best friend. By picking the right brushes and understanding the process, you'll be able to draw furry friends quickly and easily.

Using References

My number-one tip when it comes to drawing animals? Use references! References are images, often photographs or real-life observations, that artists use to gain valuable information about how a subject looks.

Learning artists often try to depend on their imaginations while drawing and find themselves in a fit of frustration when nothing looks right. However, drawing ability is heavily dependent on observational skills. Even very experienced artists rely on references to understand how to depict something. It's only after making observations that you can work on developing the skills needed to accurately (or creatively!) represent what you see.

Look at LOTS of images of a subject to identify specific characteristics. You can get very targeted with your search queries, too! For example, while trying to draw a bear, you might search for 'bear face,' 'bear walking,' 'bear fur,' etc.

Drawing on an iPad makes it easy to have references at the ready. Here are a couple of ways to have reference photos available at a glance while you work in Procreate.

iOS Split View Feature
Swipe up from the bottom to reveal the dock. Find a web browser app and drag the icon from the dock to the side of your screen to enable Split View. I use this to display image search results.

Procreate Reference Companion
Use this Procreate feature to display an image in a floating window on top of your canvas. To enable, go to the Actions menu and select 'Canvas,' then toggle on 'Reference.' Tap 'Image,' then 'Import' to select an image from your camera roll.

Procreate Reference Companion

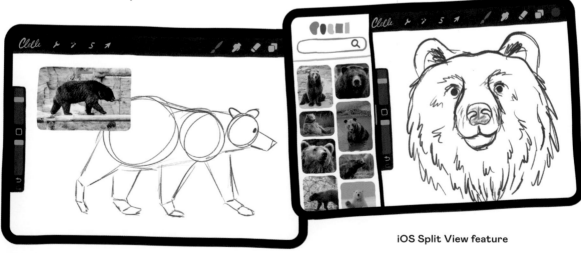

iOS Split View feature

Animal Characteristics: What Makes a Fish?

In this exercise, you'll examine many reference images, identify defining characteristics, and put together a system for drawing fish. You can apply the same process to drawing any kind of animal—or any subject, for that matter! Learning to generalize characteristics is important in finding your artistic style. The more you study, observe, and practice drawing, the better you'll become at drawing just about anything in your own unique way.

1. Do an image search for 'fish' and make some observations about each of the components of a fish. Start by making generalizations. Notice that most fish have almond-shaped bodies, at least one fin on the top, one to three fins on the belly, and a fin on each side, near the gills. Their eyes are round circles with black centers. Fish have scales, so practice drawing some scale patterns.

2. Draw a pageful each of fish bodies, fins, tails, and faces, sketching their various shapes. These shapes can be drawn freehand or traced over photos. You might even start making up your own shapes and getting creative with how you depict them. This is an excellent way to develop your own style.

3. Next, make a rough sketch using what you know about the body shape and fin placement of a fish.

4. Refine your sketch using some of the face, fin, and tail shapes you know.

5. Add in some extra details, and you've just drawn a fish from imagination.

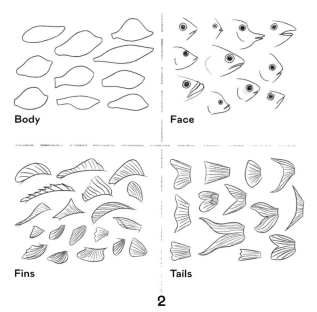

Body Face

Fins Tails

2

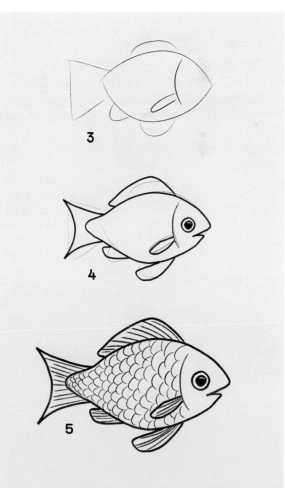

3

4

5

Project: **School of Fish**

In this project, you will create an imaginary school of colorful fish based on the knowledge you've just gained about fish bodies and fins. You'll also get to explore your brush library, experiment with color, and practice using Clipping Masks and Alpha Lock to decorate your fish with lots of fun textures and patterns.

Start With a Sketch

1. Select your pencil brush of choice and sketch several different-sized ovals on your canvas. These ovals will soon become fish, so leave plenty of space between these shapes for fins.

2. With a darker gray, trace over the ovals, turning each one into a more refined fish body. Draw a curved line on each body to define the head.

3. Now it's time for fun with fins! Recall the fish you studied on the previous page and mix and match fins and tails on the bodies.

4. Finally, draw circles to place the eyes. Your sketch is all done; time to color!

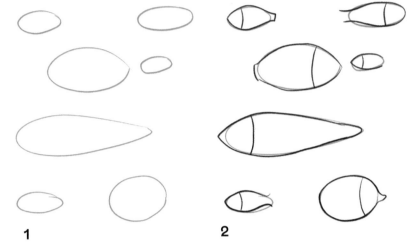

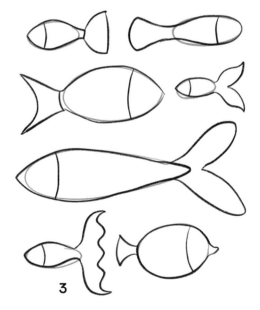

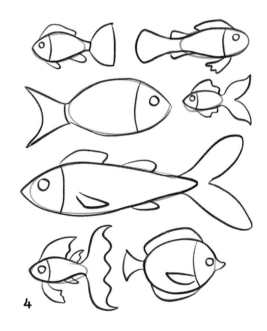

Color Play Is On the Way!

5. This piece is an excellent opportunity to play with some unexpected color combinations. Feel free to experiment, and if you don't like the way a color looks, use Color Drop to change it up. Any color palette will work; just be sure to have a mix of values from light to dark.

5

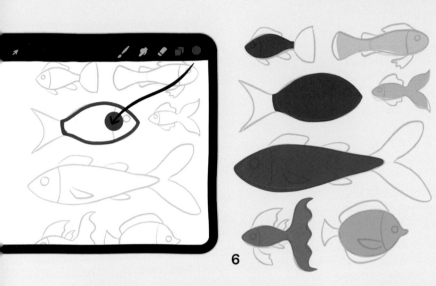

6

6. Reduce the opacity of your sketch layer, then create a new layer underneath the sketch. Using the Studio Pen brush (Inking set), outline one of the fish bodies, then fill it using Color Drop. Keep going to color all the bodies. Only include the tails on this layer if they'll be the same color as their body.

7. Create a layer underneath the bodies layer to draw all the fins and tails in contrasting or analogous colors.

8. Create a layer above the bodies layer and draw side fins on fish that have them. Next, add a Clipping Mask for the fish head shapes and one more layer to draw the eyes.

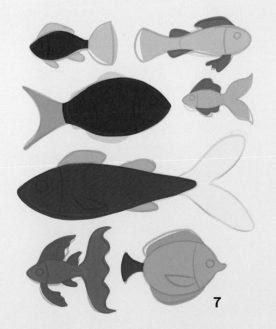

7

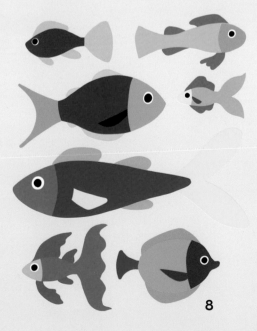

8

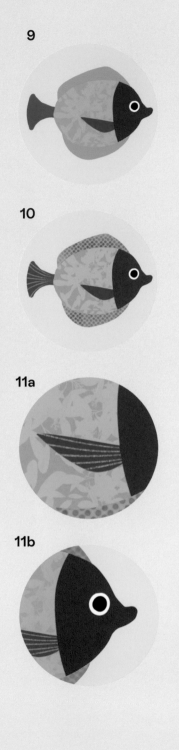

9

10

11a

11b

11

Texture & Pattern Play

Next, you'll add some interesting textures to the various parts of the fish while exploring the different brushes in your library. Have fun and see what cool textures, patterns, and details you can make.

9. Begin with the fish bodies. Create a layer directly above the bodies layer, and it should automatically convert to a Clipping Mask. Sample the body color of one of the fish, then choose a slightly lighter or darker shade. Next, choose a brush and paint a texture over the body. Repeat these steps for all the fish bodies. Try lots of brushes and experiment with color as well as patterns.

10. Select the fins layer and create a Clipping Mask above it. Repeat the previous step for the fins, drawing lines or adding textures to the top and bottom fins and tails.

11. Select the layer with the eyes and side fins and enable Alpha Lock. Draw a few lines to detail all the side fins. In my example, I used HB Pencil (Sketching set) for all of them. Finally, select the fish heads layer and enable Alpha Lock. Since you might already have a lot of patterns and textures going on, keep things simple for the heads and add a subtle texture using the Artist Crayon brush (Sketching set). Now admire your beautiful school of fish.

Sketch	N ☑
Eyes	N ☑
Head Color	N ☑
Front Fins	N ☑
Body Patterns	N ☑
Fish Bodies	N ☑
Fin Patterns	N ☑
Fish Fins	N ☑
	☑

Brushes Used

Snowgum
Organic set

Burnt Tree
Charcoals set

Procreate Pencil
Sketching set

Flicks
Spraypaints set

Little Pine
Drawing Set

Evolve
Drawing set

Inka
Inking set

Ink Bleed
Inking set

Dry Brush
Painting set

Pandani
Inking set

Fine Hair
Materials set

Styx
Drawing set

Thylacine
Inking set

Shale
Calligraphy set

Blotchy
Calligraphy set

Furneaux
Vintage set

Peppermint
Sketching set

Groovy
Vintage set

Paper Daisy
Organic set

Newsprint
Vintage set

Technical Pencil
Sketching set

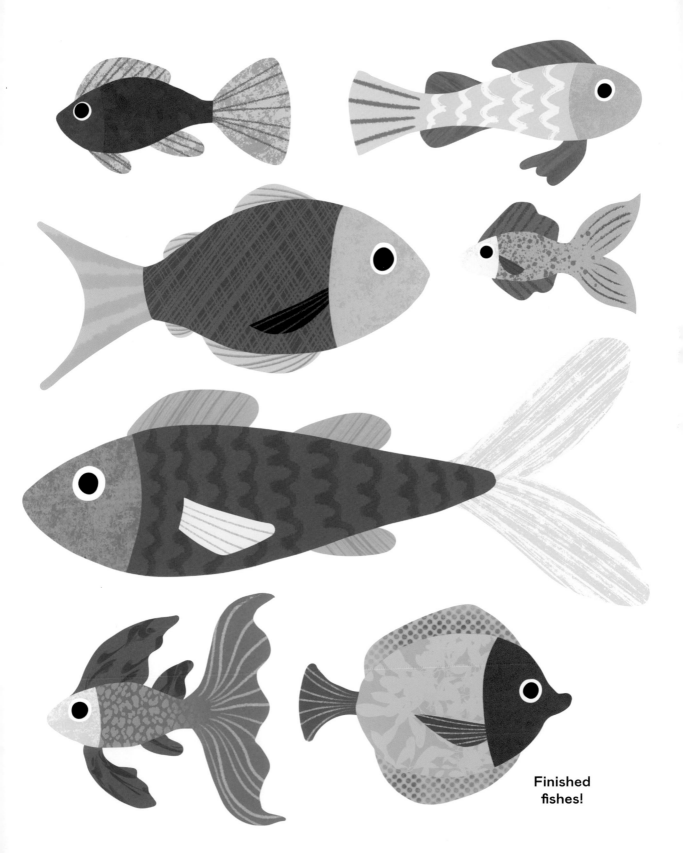

Finished fishes!

Take It From the Top: Animal Heads

Drawing animals begins with understanding how to draw their heads. As with drawing anything, you'll need to start with some basic shapes. Although animal heads come in a variety of shapes and sizes, you can use just two shapes to construct many of them: a circle and a trapezoid. The circle creates the round part of the head, and the trapezoid represents the snout or nose. You can use these shapes to draw heads in profile or front view, and you can use the 3D version of those shapes to draw animals in three-quarter view.

Animal Heads in Profile

1. When sketching an animal from the side in profile view, draw a circle with a trapezoid protruding from the front. As you look at your references, identify if the snout is long, short, sloping up or down, etc., and draw the trapezoid accordingly. Also, pay attention to the position of the eyes—in many animals, they line up with where the snout meets the head.

Animal Heads in Front View

2. You can use the same circle and trapezoid shapes when drawing an animal from the front. Start with a circle to match the overall size of the animal's head. Then use a trapezoid shape for the snout, with the top two corners aligning with the animal's eyes.

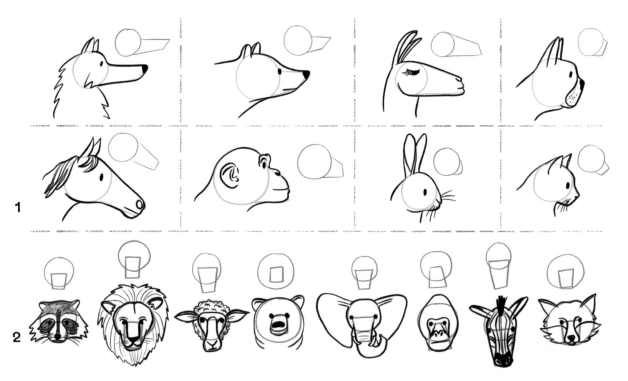

1

2

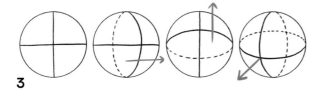

3

Animal Heads in Three-Quarter View

3. You can use a similar structure when drawing in 3D, but this time you'll use 3D forms. A sphere plus a tapered cylinder, rectangular prism, or cone can be used to construct most animals in three-quarter view.

Before going through that process, here's a little tip about spheres. Drawing curved intersecting lines on a circle helps define it as a 3D sphere. You can imagine that the vertical line runs down the center of the face, and the horizontal line goes across the middle. These lines curve as you rotate the sphere, indicating its orientation. If the animal is looking down and to the left, then the lines would curve down and to the left.

On Your Own: Draw Some Animal Heads

Choose a few animals and practice drawing their heads in profile, front view, and three-quarter view. Be sure to focus on getting the form and structure right rather than getting carried away with the details.

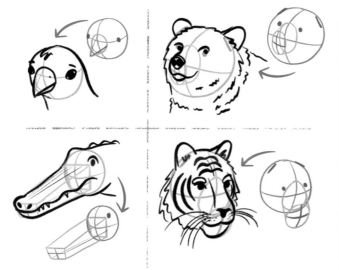

How to Draw a 3D Animal Head

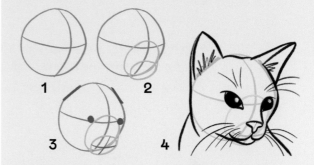

1. Draw a sphere with intersecting lines curving in the direction the head is pointing.
2. Add an oval over the lines, and another oval where the end of the snout or nose would be. Connect the two ovals to make a cylindrical 3D form.
3. Draw intersecting lines on the end of the cylinder parallel to the lines on the sphere. These lines will help you align the nose and mouth. Add a few marks to indicate the placement of eyes and ears.
4. Draw the curves and details of your animal on a new layer or in a darker color. Use the structure you made to position the facial features. For example, curve the mouth around the end of the cylinder, using the intersecting lines as a guide. Always look at reference photos of the animal you are drawing to ensure the details are accurate.

NOTE: You can use this same 3D construction to draw a variety of animal heads. Adjust the relative size of the sphere and cylinder to match the proportions of the animal you'd like to draw. Try other 3D forms for the snout when appropriate. For example, you can swap out the cylinder for a cone when drawing a bird.

Standing Tall: Animal Legs

Drawing animal legs always used to baffle me, especially dogs and horses. Which way is a dog's leg supposed to bend? It all clicked once I learned that animal legs are all made up of pretty much the same bones as human legs, just in different positions.

To understand animal legs, you need to dig into anatomy. I tend not to get too bogged down in thinking about anatomy when I draw, but it is beneficial to understand a little of what's going on beneath the skin when drawing living creatures, especially if you don't want your animals looking like they have sticks for legs.

In four-legged animals, hind legs have the same bone structure as human legs, and forelegs have the same structure as our arms. To illustrate this point, I drew you these somewhat frightening creatures with human limbs in animal proportions.

Sketch Some Legs

Look up photos of various animals and observe their legs. Think about the legs in relation to human limbs. Identify the parts of the front and rear legs that correspond to the elbow, wrist, knee, and heel in humans. Pull some photos into Procreate, and trace over the legs as if they were human arms and legs. What locomotion type is each animal? Then freehand sketch as many animal legs as possible to get yourself familiar with drawing these shapes.

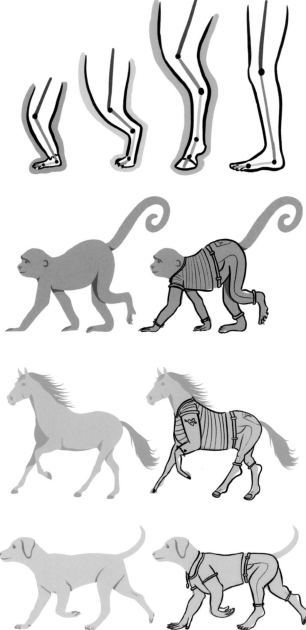

Plantigrades, Digitigrades, & Unguligrade

The monkey, dog, and horse each represent one of the three locomotion types in animals. These classifications are based on what part of the 'foot' these animals walk on.

Plantigrades walk with their whole foot, including the heel, planted on the ground. Humans are plantigrades, as are bears, primates, rodents, frogs, and kangaroos.

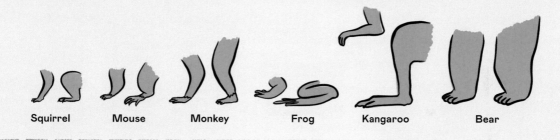

Squirrel Mouse Monkey Frog Kangaroo Bear

Digitigrades walk on their toes (digits) with the heel permanently raised. Dogs and cats are digitigrades, along with most birds.

TIP: When drawing this type of animal, imagine the paw as the toes or fingers.

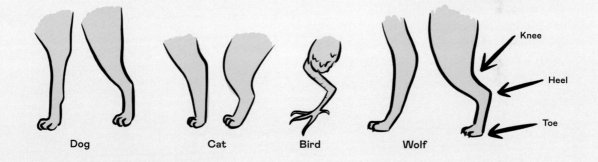

Dog Cat Bird Wolf

Knee
Heel
Toe

Unguligrade animals walk on their nails with the rest of the foot bones raised, including the ball and heel. Hooved animals, like cows, horses, deer, and camels are unguligrade.

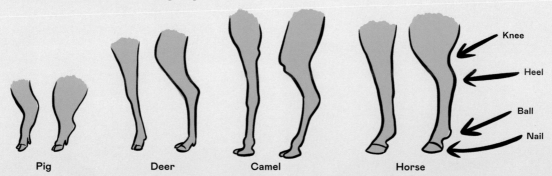

Pig Deer Camel Horse

Knee
Heel
Ball
Nail

Proportions & Exaggeration: Draw a Cow

Proportions are the relationship between the sizes of two objects or parts of a subject. Proportions are vital in making sure a subject looks readable to the viewer. Paying attention to proportions is the best way to ensure the animal you're drawing doesn't end up looking like a weird giraffe-cow monstrosity.

Understanding proportions makes you better equipped to draw that subject from memory. Let's go through this process while drawing a cow.

Get a reference photo and begin making observations. Notice how the cow's torso is the dominating feature. Use lines to divide the cow into two parts: the body and legs. These lines show that the body makes up more than half of the cow's height. Notice how the head makes up more than half of the torso's height. Also, take notice of the shapes of the body. To me, the body and head are made of trapezoid shapes. Continue to make observations. Once you've finished, it's time to start sketching.

Basic Structure
1. Sketch out the structure of the overall shape of the body, legs, and head based on the proportions you observed. Draw lines dividing the cow's overall figure into two parts to indicate that the body is more than half the total height. Draw the different parts of the cow using basic shapes and lines, avoiding any detail at this phase.

Rough Sketch
2. Next, draw the cow again with slightly more refined shapes. Add some additional curves, thicken the legs, and define the shape of the head and ears.

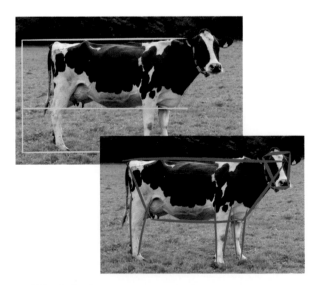

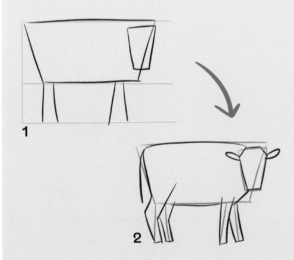

Adjust Proportions if Needed

3. Look back at your reference photo to see if the proportions look accurate. If they don't, use the Selection and Transform tools to move parts of your sketch into a better position. It's best to get all the proportions right in your rough sketch before adding final details in the next step.

Refined Sketch

4. Trace over the previous sketch to make your refined sketch. Add additional curves and details, looking to your reference photo for information about how to draw the head, legs, and body.

Finished Sketch

5. Add the final details, such as the cow's signature spots, and your sketch is complete.

Exaggerating Proportions

While there are rules regarding proportions, some rules are made to be broken. You may take creative liberties with proportions, exaggerating them to give your drawing more interest and personality. Once you make some generalizations about the proportions of a subject, you can use that information to make stylistic choices about how you want to draw it.

For this second cow, I emphasized its large torso by adding more heft to the body. I also made the head smaller. I decided to simplify the legs a bit and smooth out the curve on the cow's back. All these choices lead to a more stylized cow infused with personal artistic style. Exaggerating proportions is all about understanding where you can push things while keeping your drawing readable and believable.

Brushes used to finish this drawing
Main shapes: Dry Ink (Inking set)
Texture, grass: Burnt Tree (Charcoals set)
Shading: Vine Charcoal (Charcoals set)
Face details: 6B Pencil (Sketching set)

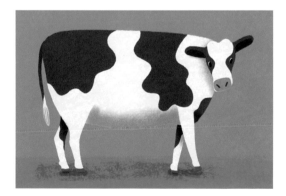

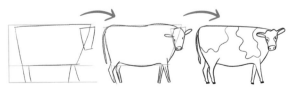

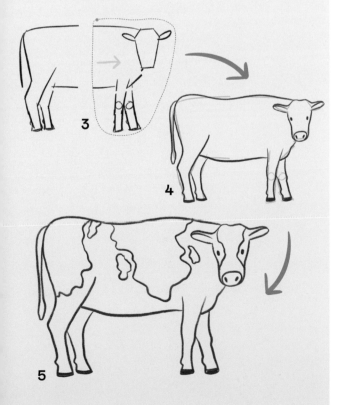

Project: Draw a Furry Dog

It's time to put together the animal drawing and digital art skills you've practiced so far and learn some new ones. By illustrating a cute Border Collie, you'll learn how to sketch an entire animal body, render long and short fur in multiple colors, create shading with blend modes, use layers, Clipping Masks, color palettes, and much more.

Part 1: Constructing the Dog Sketch

Proportions & Pose

1. Start by laying out the proportions of the dog. For this Border collie, the legs make up more than half of the total height of the dog, so mark a line above the midpoint. Draw some lines to represent the length of the body and head, pose the legs, and then add a circle for the head. This step is about getting the proportions right rather than drawing detailed shapes.

Build a Skeletal Structure

2. Reduce the opacity of this layer and create a new one. Draw ovals to represent the ribcage and hips, then connect the two with a curved line to form a spine. Trace over the circle for the head. On the legs, add circles to indicate the leg joints. Place the 'knee' joints in front of the leg line and the 'heel' joints behind it. Connect these joints with lines.

Thicken Up the Frame

3. Now that you've got a skeletal frame, add some bulk to it with more curves and lines. Loosely define the body shape and legs.

4. Build the head by starting with a sphere and adding a tapered cylinder. This particular dog has a very thick coat, so draw some jagged lines away from the body to define the shape and volume of the fur.

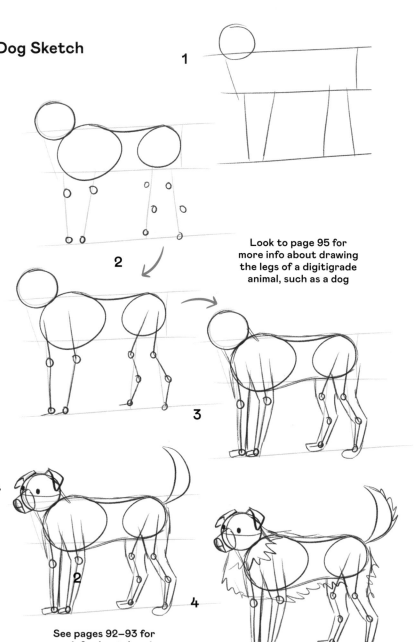

Look to page 95 for more info about drawing the legs of a digitigrade animal, such as a dog

See pages 92–93 for more info about drawing animal heads

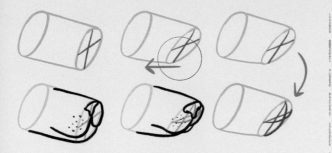

Snout Looking a Little Flat?

A snout drawn over a perfect cylinder can appear stiff and inaccurate. To correct this, you'll need to angle the end of the cylinder.

1. Drawing an angled cylinder can be tricky, so you can use the Liquify tool to push it into position.

Draw the snout on its own layer to prevent liquifying the sphere shape. You can merge the two layers after.

2. Add some curved lines to the front of the cylinder to 'puff up' the front of the snout. Now you can draw a snout that looks more like a snout and less like a soda can.

Pause On Paws

Here's how to draw a paw. Start at the base of the leg and draw a line out to become the top of the paw. Then draw an angled line down, like the end of an arrow. Next, draw another arrow line close to the first, then another further away. Finally, connect all these lines with curves to form the bottom of the paw. This is detailed enough for our sketch, but if you wanted to keep going, you could draw in the claws and pads.

Refine the Sketch & Define the Fur

5. Turn off the layer with the proportion lines and reduce the opacity of the skeletal layer. Create a new layer for your refined sketch. Trace over your rough sketch to define this doggy's details. Finish your sketch by adding a few lines indicating where each fur color will go.

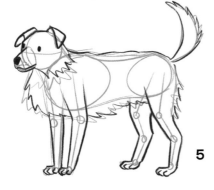

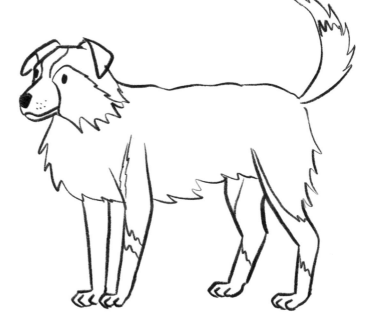

Draw a Furball: How to Render Fur

Before continuing with your dog, take some time to learn the fur-rendering method we'll use for this illustration. Let's do a fur study. Feel free to revisit these steps as you work on your dog. Exit back to Gallery View and create a new file for this study.

Make a Furry Base

1. When drawing fur, start with a color darker than the actual fur color as your base. Since we want to make white fur, we'll start with a darker, off-white base. Using the Blackburn brush (Drawing set) at a small size, draw a circle in off-white/tan. Then make some short strokes along the bottom to create rough, furry edges. Switch to the Smudge tool and select Copperhead (Drawing set) as your smudging brush. With very light pressure, make rounded flicking motions over the furry edges of the ball to fluff up and soften them. You can also paint in additional furry strokes with Copperhead as your brush if needed.

Create Multiple Fur Colors

2. It's time to add the other fur colors. Create a Clipping Mask above the ball layer. Select an orange color for the ginger fur. Again, be sure to select a shade slightly darker than your final intended fur color. Paint over the ball, then create a rough furry texture along the visible edge, as in step 1. Grab the Smudge tool and soften the furry edge. These should be downward strokes moving from the orange color to the tan. Create another Clipping Mask and repeat these steps to add a layer of fur in dark gray (not black).

Add Overall Fur Texture

3. Enable Alpha Lock on the ball layer. Select Copperhead as your brush and white as your color. Reduce the opacity of the brush to half. Starting at the bottom of the ball, add lots of short, rounded strokes in the direction of the fur. Work your way up until the entire tan area is filled with white fur texture. Select the orange fur layer and repeat the process with a lighter orange color. Be sure to vary the curve of these strokes slightly and leave some of the dark orange base color visible. For the black fur, choose a lighter gray in a cooler tone. Continue to add fur strokes over the area, starting at the bottom and working your way up to the 'part' in the hair. Notice how I placed the fur strokes in a brick-by-brick pattern, leaving parts of the darker base color visible.

TIP: When switching between many brushes in different sets, save time and use Procreate's Recent Brushes feature, which is located at the top of the Brushes panel. Swipe to the left on a recent brush and tap Pin to keep it permanently at the top of your Recents set.

Apply Shading

4. The final step in rendering this fur is adding a bit of shading. Create another Clipping Mask on top of the others and set that layer's blend mode to Multiply. Select the Medium Nozzle brush (Spraypaints set) and reduce the brush's opacity to half. Select a warm middle gray—the two colors I used to paint this shadow are shown to the left. Paint over one side of the ball opposite the imagined light source. Due to the low opacity of the brush, you can build up the darkness by layering strokes. You might need to use a darker color for the darkest parts of the shadow.

Paint On Highlights

5. Choose the Copperhead brush as your Eraser and turn down the opacity of the brush. Erase a few strokes along the top edge of the shadow to blend the shape into the fur texture. To add dimension and highlights in the shadow area, erase a few strokes in the middle of the shadow shape. Go back to the black fur layer and select a warm dark gray that is lighter than the one used to make the fur texture. Paint on a few more strokes to create highlights on the brightest part of the fur, in the direction of the imagined light source. If needed, add a few highlight strokes to the other fur colors.

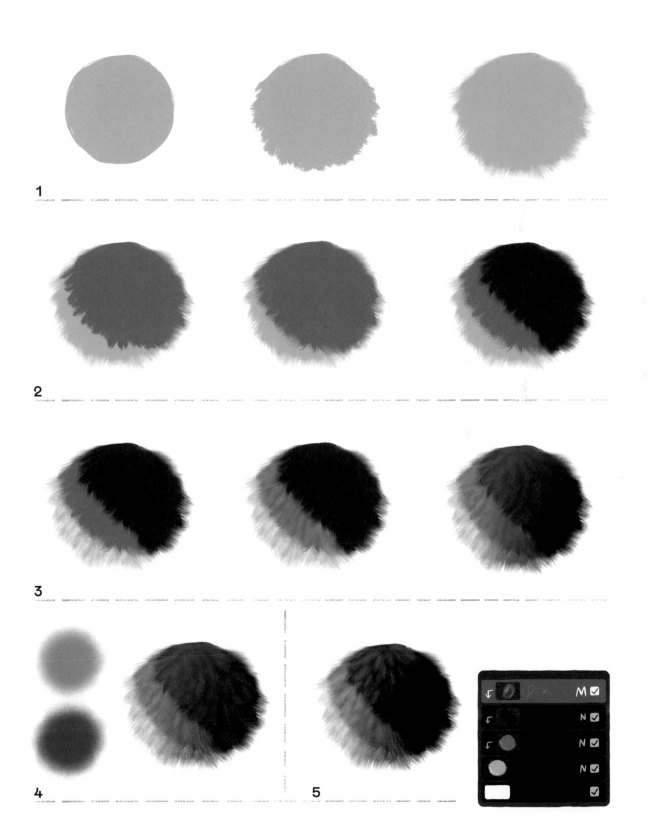

1

2

3

4

5

Part 2: Rendering the Furry Body

Apply what you've just learned through drawing the furball to render the fur on this dog. You'll focus on just one part of this dog illustration at a time before moving on to other layers. Reduce the opacity of your sketch and create a new layer underneath the sketch layer.

Set Up Fur Colors as Layers

1. Select a tan color and the Blackburn brush and draw the shape of the body and foreground legs.

2. Use short strokes of the Blackburn brush to make some rough fur edges.

3. Use Copperhead as your Smudge tool to soften the fur.

4. Create a Clipping Mask, paint in the orange fur areas, and then smudge the edges using downward strokes.

5. Make another Clipping Mask and repeat the previous step to create the black fur layer. Be sure to use a dark gray, not black.

Texturize the Fur

6. Tap back to the tan layer and enable Alpha Lock. Select the Copperhead brush, lower the brush opacity, and, starting at the bottom of the paws, apply short strokes to fill in the fur texture. For very short hairs such as these, make the brush size smaller. The shorter the fur, the smaller your brush size should be. Move up to the chest fur.

Make downward strokes, working your way toward the top of the shape until it's completely filled. Next, paint in the fur texture on the orange layer using a lighter orange color. Move on to the black fur layer, using a lighter, cooler gray, a larger brush size and slightly longer strokes.

7. Finish filling in the black fur, slightly varying the direction of these strokes, and be sure to leave the base color peeking through.

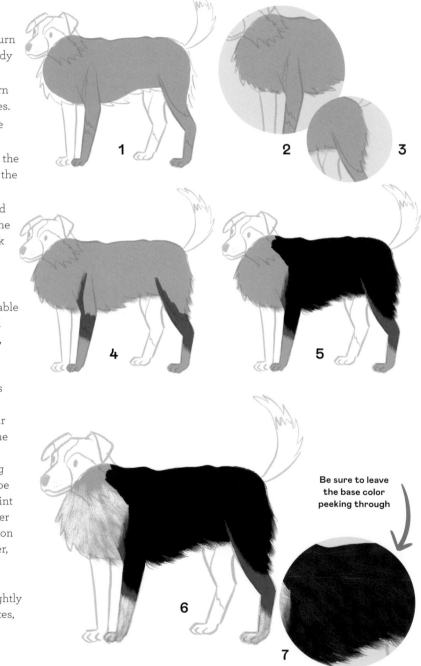

Be sure to leave the base color peeking through

TIP: Since you'll be cycling through the same colors several times, it's a good idea to save them in a Color Palette for consistency and easy recall.

Paint In Some Shading

8. Create another Clipping Mask with its blend mode set to Multiply. Use the Medium Nozzle brush to paint in a shadow along the dog's underbelly and back of its legs. Use a smaller brush size on the legs to be more precise with the shadow. Then use Copperhead as your Eraser to erase part of the shadow's edge and add a few strategic highlights within the shadow.

Go back to the different fur layers and add light strokes with the Copperhead brush to create even more highlights.

Repeat the Process for the Background Legs & Tail

9. Create a new layer and place it beneath the body layer. Paint in the shapes of the background legs and tail. Make a Clipping Mask and use it to paint in the orange coloring of the back leg. You can also use this same layer for the black on the tail, because those two areas do not touch or overlap. Smudge the edges of the fur to soften.

10. Using the same process as the previous section, paint in overall fur texture on the white, orange, and black fur.

11. Create a Clipping Mask set to Multiply to paint in shadows over the tops of the legs and backs of the tail. Use the Eraser to texturize these shadows and add a few highlights.

8

9

Draw the base
shape

10

Add overall
texture

11

Create shading

Part 3: The Dog's Head

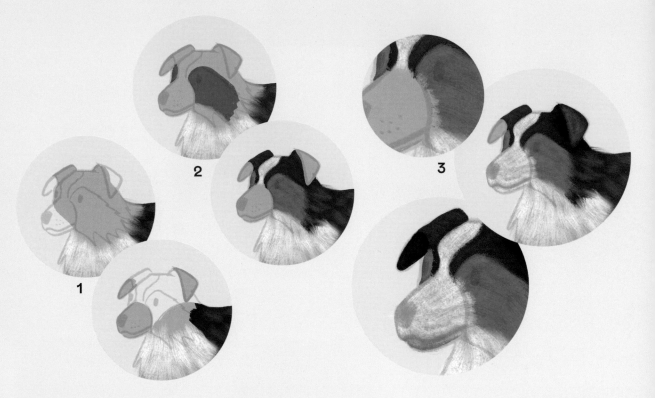

Make New Layers for the Head Shapes

1. Create a layer above the body fur layers. Draw the shape of the entire head except for the snout, top of the front ear, and back of the back ear—you'll place these on separate layers. Be sure to blend the furry edge of the head shape with the Smudge tool. Make a layer above the head and draw the snout and front ear.

TIP: Temporarily turn off visibility of the head layer so it's easier to see what you're drawing. You can reuse the body shape layer for the back of the back ear instead of creating another new layer.

Add Coloring & Fur Texture

2. Create a Clipping Mask above the head layer and paint in the orange coloring. Texture the bottom edge with the Smudge tool in a downward direction. Create another Clipping Mask and paint in the dark gray coloring. Smudge all the edges in the direction of the fur. When smudging on the top of the head, use a very small brush size to create the appearance of short hair. Add fur texture to each of the colors.

3. Tap over to the layer with the snout and front ear and use Color Drop to change the ear to the dark gray base color. Use the Smudge tool to blend the back edge of the snout where it meets the head. Enable Alpha Lock on that layer and paint in the fur texture. Beginning at the nose, paint fur strokes in a direction that matches the contour of the snout. Texturize the ear, then add a few strokes of your highlight color. Use a Clipping Mask set to Multiply to add a bit of shading to the underside of the snout. Finally, color and texturize the back ear, located on the main body layer.

Part 4: Illustrating the Facial Features

Nose

1. Create a new layer above the head layers. Select Blackburn and make the brush size very small. Use dark gray (not black) to paint the shape of the nose. Use the Smudge tool with Copperhead to blend the edges of the nose into the snout. Turn on Alpha Lock, select the Medium Nozzle brush and use a brown color to paint over the fury edges. Use the 6B Pencil brush (Sketching set) to draw in the details of the nose—black for the nostrils and a lighter gray for the highlight on the top edge of the nose.

Mouth

2. Use Blackburn at a small size to draw the line of the mouth in brown. Use the Smudge tool to make downward strokes over the top of the line to make it appear as if fur is covering it a little bit.

Eyes

3. There are many ways you could draw the eyes, but I like to use a stylized, slightly cartoonish style. Use the same layer as the nose to draw the whites of the eyes. Because the head is in three-quarter view, one of the eyes will be foreshortened and go over the edge of the head. You might want to set a background color if it becomes hard to see what you're drawing. Create a Clipping Mask above the nose and eye layer. Draw in the pupils of the eye in dark gray. Use 6B Pencil to add a slightly lighter spot of gray near the top of the eye and white to make highlights. Finally, sample the orange fur color, then choose a darker, redder version of that color. Use the Copperhead brush to paint some furry strokes around the eye.

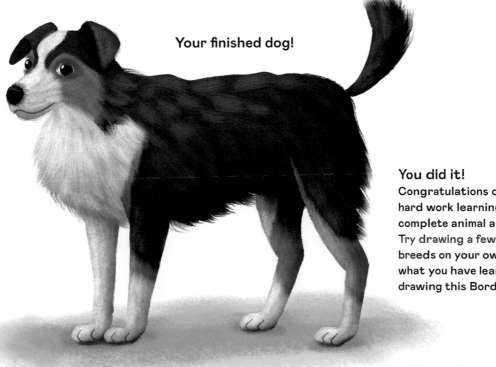

Your finished dog!

You did it!
Congratulations on all your hard work learning to draw a complete animal and render fur. Try drawing a few other dog breeds on your own and apply what you have learned from drawing this Border Collie.

6
People & Characters

Do you have good people skills? Drawing people can seem very intimidating, especially for beginner artists. I'll introduce you to the basics, so you can develop your people-drawing skills one step at a time. The goal of this chapter is to help you draw people stylistically, and there are so many possibilities within style. But in order to stylize something, it's necessary to understand how that thing looks realistically. Then you, as the artist, can subtract detail and add flair to achieve a particular aesthetic.

As we zoom out from the smaller details of drawing people, such as facial features, to the big picture—illustrating an entire body, complete with hair and clothes—we'll also progress from drawing semi-realistic people, to stylized, to simple. I'll take you through the fundamentals of facial features, proportions, hair, and clothing details so that you have the foundations to experiment and develop your own people-drawing style.

Let's get started!

Studying the Facial Features

Knowing how different body parts look in real life is essential for drawing people in your own style. Take some time to observe and draw the features of the face. On this page, you'll find some step-by-step images, along with drawing tips from me. I encourage you to find reference photos (or look in the mirror!) and draw what you see. The more studies you do, the better equipped you will be to draw stylized people!

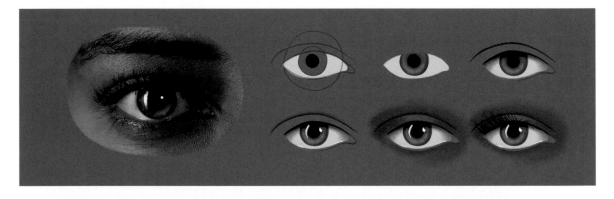

Eye

When I draw eyes, I use lots of layers to separate out the different parts, such as the main shape, the iris, the pupil, shadows, highlights, and details. I use Alpha Lock to add texture and coloration. For the shading within the eye, I use a Clipping Mask, along with the multiply blend mode.

Mouth

I draw the whole shape of the mouth on one layer, then use a clipping mask to add line details. After that, I use Alpha Lock on the mouth shape to add distinct shading to make it appear more realistic. The top lip appears darker than the bottom lip because of the way the light hits it.

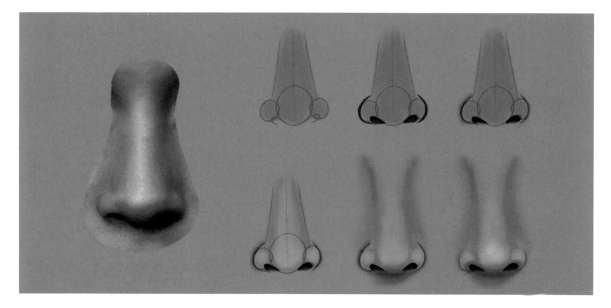

Ear

I find ears really fun to draw! This ear is drawn using a single layer. I start with the shape, then define the darkest areas and sharp edges. With Alpha Lock on, I continue to add lighter and darker shadows and highlights. A little pop of redness along the edges makes it look even more realistic.

Nose

Noses can be tricky to draw, as they are mostly made up of soft shading. I start with a color darker and redder than the base skin tone. The sharp details are on a separate layer, but I shade everything else on the bottom layer. Then I start adding highlights and shadows to give the nose dimension.

Facial Proportions

Following the rules of facial proportions helps you draw a face that looks balanced, even when stylizing and exaggerating features. Faces come in an infinite number of shapes and sizes, but they all follow pretty much the same guidelines. Study the facial proportions diagram below, and try drawing one of your own.

The rules don't need to be strictly followed when drawing stylized people, but if something seems odd, check your proportions and tweak things accordingly. As you become more familiar with these proportions, you'll have an easier time estimating them in your drawing without agonizing over each measurement. Here's how to draw a quick facial proportions diagram you can use to draw faces.

 The space between the eyes is equal to one eye's width.

The space from ear to ear is five eyes wide.

Eyes are at the midpoint of the head's total height.

The height to the ear is from the brows to the bottom of the nose.

The bottom of the nose is halfway between the brows and chin.

The sides of the nose line up with the tear ducts.

The corners of the mouth line up with the pupils.

From nose to mouth is half the distance from eyes to nose.

Draw a Simple Facial Proportions Guide

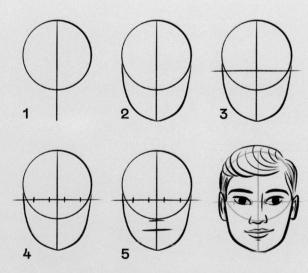

1. Draw a circle with a line down the center to define the total height of the head.
2. Connect the line to the circle with curves to form the jawline.
3. Estimate the midpoint of the head and draw a horizontal eye line.
4. Draw four equally spaced lines along the eye line to define the placement of the eyes.
5. Place the nose line halfway between the eye line and chin. Place the mouth line one-third of the way down from the nose to the chin.

Shading the Face

Let's demystify facial shading, shall we? Since the face is a rather complex surface, I prefer to generalize when shading it. The diagrams on this page show you a realistic model for facial shading. For stylized art, I like to shade only the parts of the face that are the darkest (under the nose, the inside corners of the eyes, the sides of the head, and the corners of the mouth) and the lightest (nose, cheeks, and chin). The shading of the face can change drastically depending on the surrounding lighting situation, but these diagrams will give you a guideline for shading without knowing the light source.

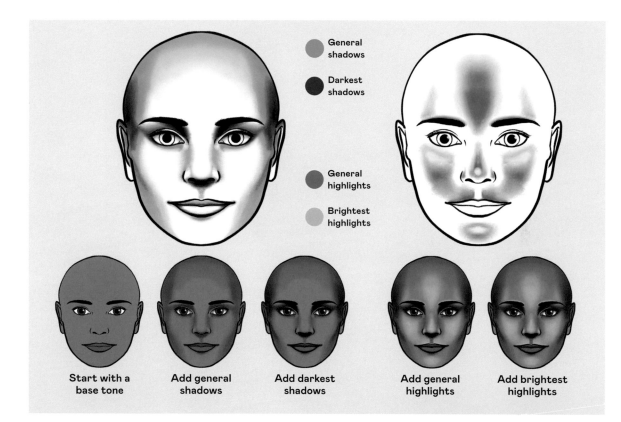

General shadows

Darkest shadows

General highlights

Brightest highlights

| Start with a base tone | Add general shadows | Add darkest shadows | Add general highlights | Add brightest highlights |

Choosing Colors for Skin

Two important things to keep in mind when choosing colors for skin shading are to shift the hue and mind the saturation. Don't just choose a lighter or darker version of your base skin tone. Skin shadows are often redder and more saturated. Highlights can be closer to yellow. You can experiment with skin-tone colors by placing each value on its own layer, then using the Hue, Saturation, Brightness adjustment to fine-tune.

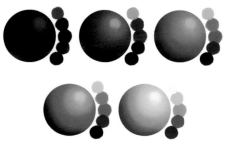

Skin-tone palettes

How to Draw Hair

Drawing hair with depth, texture, and volume requires five essential elements: overall shape, stray hairs, texture/direction lines, and shadows and highlights. Despite the many textures, lengths, styles, and colors of hair, the method to draw each is pretty much the same—the key is matching those five elements to the texture of the hair, whether it is straight, wavy, curly, or coily. On these pages, I'll show you one way to draw stylized hair, but these steps can be used to draw hairstyles in all kinds of artistic styles.

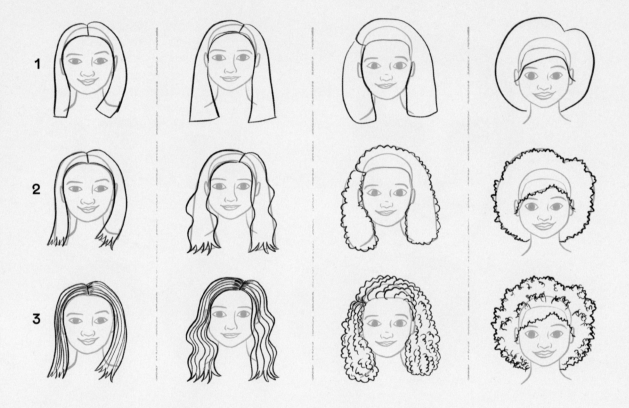

How to Sketch Hairstyles

Hair can be tricky to draw, so I always recommend looking at reference photos to help.

1. After drawing a face, define the hairline on the head. Then draw the basic shape of the hair with smooth lines, making sure you draw the hair away from the edge of the head to give it volume. The more textured the hair, the more volume it should have.
2. Next, draw the shape of the hair with more detail and curves to match the hair's texture—smooth for straight, bubbly for curly, etc.
3. Finally, add lines to define the sectioning, direction, and texture of the hair.

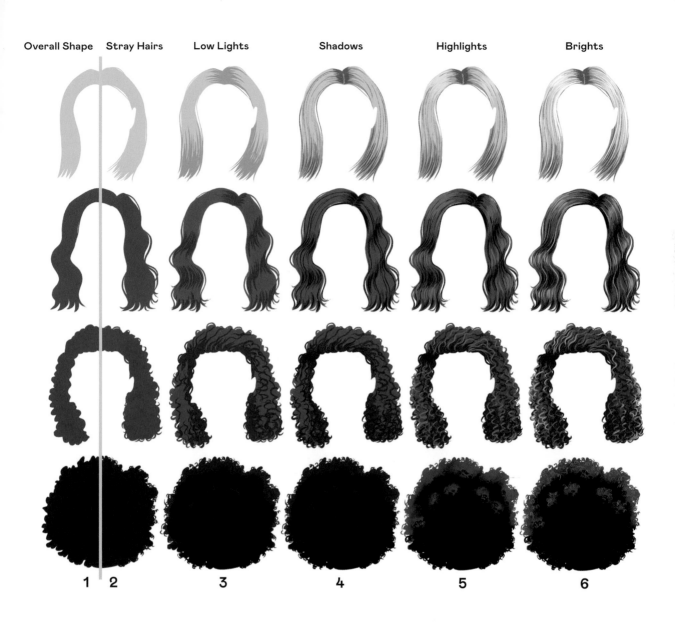

Overall Shape	Stray Hairs	Low Lights	Shadows	Highlights	Brights

1 2 3 4 5 6

How to Render Hair in Color

1. Draw the overall shape of the hair in a base color.

2. Draw stray hairs and strands around the edges of the shape. Now you'll start layering the different values. It's a good idea to create a layer for each value in case you need to adjust the colors.

3. Using a Clipping Mask, add strokes to create the lowlights.

4. Further define these dark areas with an even darker value. Use this color to draw some individual strands as well.

5. Paint the highlights in a lighter color than the base. For placement, consider where light would naturally hit the hair, or look at reference photos.

6. Using a lighter value, add a few bright spots and some individual strands to the hair.

Project: Stylized Self-Portrait

It's time to draw your first full face, and what better face than the one you're most familiar with—yours! In this project, you'll draw a stylized self-portrait, which means you can take creative liberties with the facial features and proportions. Before you begin, sketch some stylized features and decide which style appeals to you. You can even do some thumbnail sketches of faces to try out different feature combinations. Then, when you're ready, let's make a face.

Part 1: Sketching the Face & Hair

Since faces are pretty symmetrical by nature, Procreate's Symmetry Guide can assist you in drawing and adjusting your facial features. Go to the Actions menu and select 'Canvas,' toggle on 'Drawing Guide,' then tap 'Edit Drawing Guide.' Tap over to the 'Symmetry'

mode, then tap 'Options' to make sure 'Assisted Drawing' is turned on. Tap 'Done'. With Drawing Assist enabled, anything you draw on one half of your canvas will be mirrored on the opposite side.

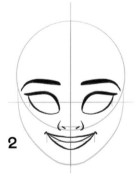

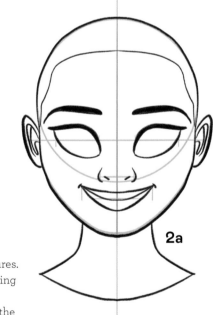

Lay Out the Proportions

1. Begin by drawing a facial proportions guide (page 110). You can use the QuickShape feature (page 30) to make perfect circles and lines. This stylized face will mostly follow standard proportions rules except for the eyes, which I'm choosing to make oversized.

Draw the Facial Features

2. Make a new layer to draw the features. When working with Procreate's drawing guides, you must enable Drawing Assist for each layer you wish to use the Symmetry feature on. Turn on Drawing Assist on this new layer from the Layer Options menu. Draw the different facial features. There are many ways to draw eyes, noses, mouths, and ears, so feel free to get creative.

2a. Draw the face shape and neck and define the hairline. Go ahead and turn off the Drawing Guide in the Actions menu to hide the line down the middle of the screen.

Making Perfect Pupils

3. For the iris and pupils, create a new layer and turn on Drawing Assist. Draw a circle or oval for the pupil and color it in, then draw a concentric circle around it for the iris. Turn off Drawing Assist. You can leave the pupils here as is, but I love a side glance, so I'm going to move them to the right. Erase any lines you don't need.

Use Liquify to Make It More 'You'

4. Here's a fun tip for making your face sketch look more like you. Tap back to the face sketch layer with Drawing Assist enabled. Use the Liquify tool (page 31) to push the face shape and features around until it's more 'you.' Look in a mirror or at a photo of yourself for guidance.

Sketch Your Hairstyle

5. Make a new layer and draw the overall volume of the hair with a basic shape.

Then make another layer to sketch the hair shape in more detail. Add texture and direction lines over the hair shape.

When you're done, you can erase any parts of the face sketch beneath the hair, then merge the two layers to complete your final sketch.

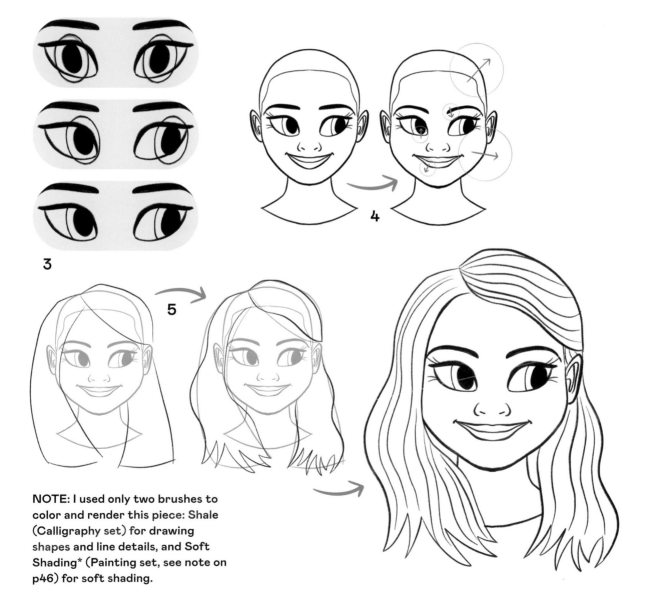

NOTE: I used only two brushes to color and render this piece: Shale (Calligraphy set) for drawing shapes and line details, and Soft Shading* (Painting set, see note on p46) for soft shading.

Part 2: Coloring & Shading the Face

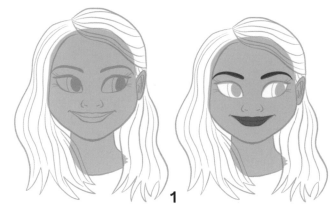

Shape the face & features

1. On a new layer under the sketch layer, begin drawing the shapes of the face.

Create a new layer and draw the eyes, lips, and brows.

You can turn on Drawing Assist for this layer to ease the process.

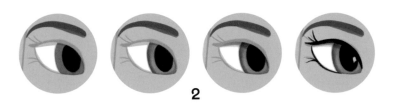

Create the Eye Details

2. Follow a similar process to the one on page 108 to draw the eye details. Make Clipping Masks for the iris and pupil. Add detail to the iris using Alpha Lock. Use a Clipping Mask set to Multiply to make eye shading. Create a line on top of all those for lash lines and a shiny reflection.

Shade the Skin

3. Next, add some simple shading to the face. Use the Smudge tool to soften when needed. To illustrate placement, I have shown the shadows in blue and the highlights in orange, but you should paint them in skin-tone values.

Use a Clipping Mask above the face shape layer to paint the shadows. Use Alpha Lock to add a shadow to the chin and ear. Paint the highlights on the same Clipping Mask as the shadows. Finally, add some rosiness to the skin.

Make another Clipping Mask and set its blend mode to Multiply. Choose a very light pink and brush it over the cheeks and nose.

Now that you've finished shading, choose an appropriately dark color to paint and draw the line details for the nose and ear.

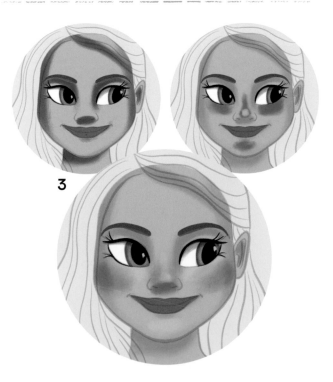

Plump up the lips

4. Let's reuse some layers to shade the lips. Tap back to the Clipping Mask with the irises and draw the top lip in a darker shade. Use Alpha Lock to add a little lightness to the middle of the bottom lip and upper part of the top lip. Add a subtle shine mark to the bottom lip. Use the eye-shading layer to shade the corners of the mouth

Part 3: Rendering the Hair

Draw the Hair Shape

1. For this piece, we'll do a simplified version of the hair method on pages 112–113. Draw the overall shape of the hair. The number and placement of layers you'll use for hair will vary depending on your hairstyle. I used two layers for mine: one for the hair behind the ear and another for the hair in front of the face. Since I wanted the hair to go behind the ear but over the neck, I needed to cut and paste the ear on to its own layer. Add some stray hairs to their respective hair layers. Make a layer under the neck to fill in the hair behind the head.

Add Texture & Shading

2. Create a layer above each hair layer to draw the texture and direction lines in a darker color. Enable Alpha Lock on the hair layers, then softly shade in some highlights and shadows.

Bonus! Adding a Glow Effect

It's quite simple to add a dynamic lighting effect like this glow. First, we need the entire illustration on a single layer. You can do this non-destructively with the Copy Canvas feature. First, turn off the visibility of the Background Color layer. Go to the Actions Menu > Add. Tap 'Copy Canvas' then tap 'Paste'. You'll see a new layer with all visible layers merged into one. Move this merged layer to the top of your layers panel, then turn on the Background Color to continue.

Create a Clipping Mask above the merged layer and set its blend mode to Add. Choose a light, warm, mid-saturated color. I've shown you the colors used for my piece, but experiment to see what works best for yours. The lighter the color, the brighter the glow. Decide where your imagined light source comes from (opposite the chin shadow is a good clue) and paint over the outer edge of the hair with Soft Shading* (see note on p46). Next, paint over one side of the face and nose, like shown. Erase with the Shale Brush to refine the glow, then paint with Shale to create a few glowing strands. Smudge with Soft Shading* to soften these lines a bit.

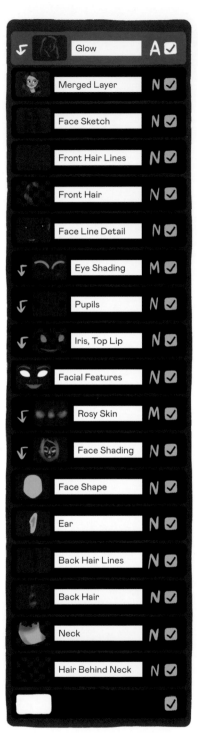

Before

After

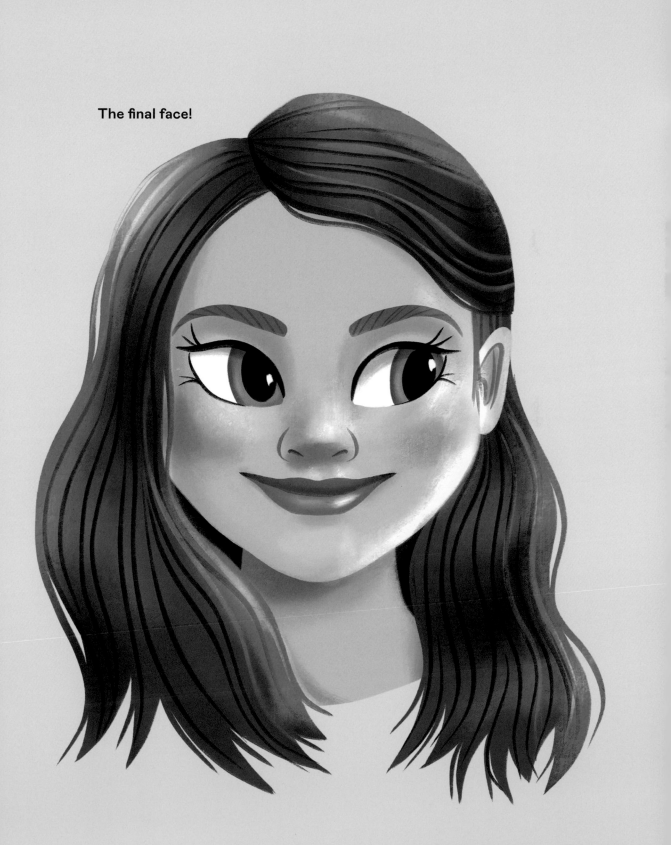

The final face!

Body Proportions

Just like with the face, there are relationships between the different parts of the body. Understanding these relationships will help you draw bodies that look balanced and natural.

Below, you'll find a detailed list of body proportion rules. Let's start with the first rule, which will help define all the others: the average body is between seven and a half and eight 'heads' tall. I like to use eight because it is easy to divide.

We'll use the head as a unit of measurement—I'll refer to it as a head-unit.

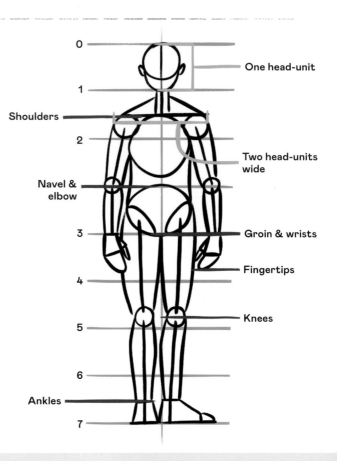

0

One head-unit

1

Shoulders

2

Two head-units wide

Navel & elbow

3

Groin & wrists

Fingertips

4

Knees

5

6

Ankles

7

Rules for Body Proportions

Torso
- Collarbones are about half a head-unit below the chin.
- Shoulders are about two head-units wide.
- The navel is about three head-units down from the top of the head.
- The groin represents the bottom of the torso and is at the midpoint of the body.

Arms
- Elbows line up with the navel.
- Wrists line up with the groin.
- Hands fall to the mid-thigh.
- The upper arm is longer than the forearm.
- The hand is between two-thirds and three-quarters the length of the forearm.

Legs
- About half the body is legs (the legs, from groin to heels, equal the distance from head to groin).
- The knees are just above the midway point between the groin and the heels.
- The ankles are about half a head-unit up from the heels.
- The widest part of the calf muscle is one-third of the way down the calves.

Key Rules to Remember

You don't have to follow all these rules to the letter, especially when stylizing the body. Feel free to push proportions, and if something looks 'off,' you can nudge things back toward these detailed proportion rules.

When in doubt, think:
- Legs should make up about half the body.
- Knees are above the midway point between the groin and the heels.
- Hands go down to the mid-thigh.

With all that in mind, here's how to draw a skeletal frame you can use to draw bodies.

1. Draw lines to define the shoulders and hips. Add a line down the center for the spine.

2. Draw ovals to define the chest, hips, shoulder joints, and hip joints.

3. Add the head on top. Now that you have the height from head to groin, you know how long to make the legs.

4. Define the knees, ankles, and feet. Tip: Look back to page 37 to see how to construct feet.

5. Add the arms and hands. Remember the proportion rules—elbows at the navel, wrists in line with the groin. Draw basic shapes for the hands. Draw lines to form triangular shapes on top of the shoulders.

6. Your skeletal frame is complete.

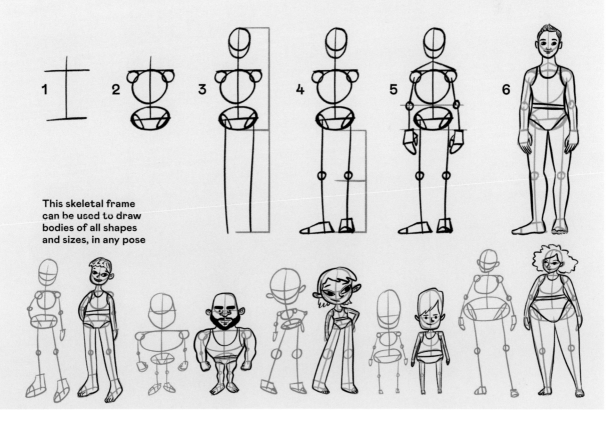

This skeletal frame can be used to draw bodies of all shapes and sizes, in any pose

Clothing Details

Once you've drawn a body, chances are
you'll want to dress it up. On these pages,
we'll look at lots of ways you can turn
basic clothing into something special
by adding cuffs, collars, wrinkles, ruffles,
stripes, stitches, and more.

Fabric: Bunches, Ruffles, & Pleats

Create ruffled fabric with a
curving line. Draw lines up
from the apex of the curves.
Both styles below use the
same curved line—the only
difference is which curves
are in the foreground.

Converging lines
make fabric look
like it's hanging
from a single
point.

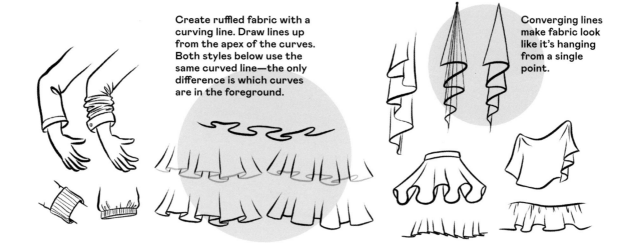

Collars

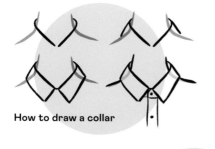

How to draw a collar

How to draw a hood

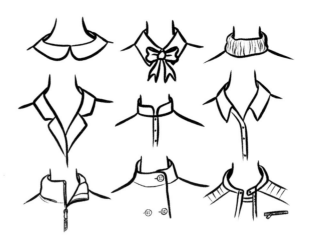

Sleeves

Prints & Patterns

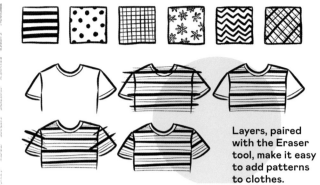

Layers, paired with the Eraser tool, make it easy to add patterns to clothes.

Fasteners

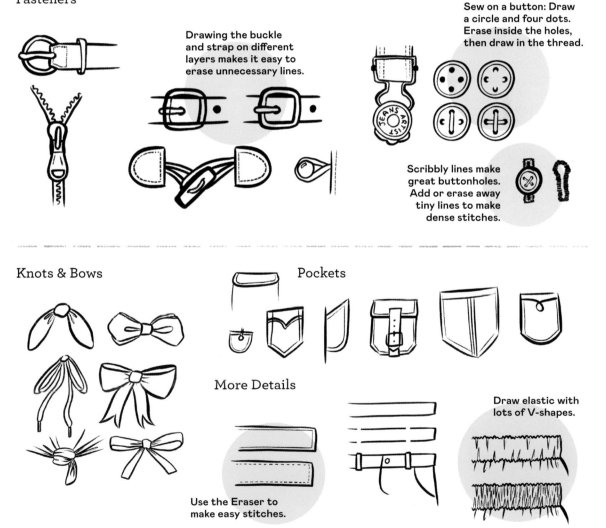

Drawing the buckle and strap on different layers makes it easy to erase unnecessary lines.

Sew on a button: Draw a circle and four dots. Erase inside the holes, then draw in the thread.

Scribbly lines make great buttonholes. Add or erase away tiny lines to make dense stitches.

Knots & Bows

Pockets

More Details

Use the Eraser to make easy stitches.

Draw elastic with lots of V-shapes.

Project: Build-a-Character

Put your people-drawing skills into practice to draw a full-body character, complete with clothes and accessories. You'll learn how to make a body base that you can 'dress' in clothes, as well as how to use layers to experiment with different clothing options. And the best part? This project is actually a game! Discover the details about your character's appearance with the roll of a die.

I've provided lists of different physical traits, clothing, and accessories. You'll need a die or other way to choose a random number between one and six. Roll to define your character's skin tone, hair type, clothing, and accessories. There are more options than those listed here, so feel free to add your own if inspiration strikes. Get ready to roll—it's time for a spontaneous drawing session.

Let's go!

Skin & Hair

Hair length
1. Long
2. Medium
3. Short
4. Receding
5. Buzzed
6. Cropped

Hair color
1. Brown
2. Black
3. Blonde
4. Auburn
5. Red
6. Silver

Hair texture
1. Straight
2. Loose waves
3. Tight waves
4. Curly
5. Coily
6. Kinky

Skin tone
1. Dark
2. Medium
3. Olive
4. Bronze
5. Fair
6. Pale

Clothing

Bottom
1. Jeans
2. Skirt
3. Sweatpants
4. Wide leg pants
5. Overalls
6. Shorts

Top
1. T-shirt
2. Collared button-up
3. Crop top
4. Tank top
5. Tunic
6. Sweater

Outerwear
1. Raincoat
2. Blazer
3. Denim jacket
4. Cardigan
5. Peacoat
6. Hoodie

Shoes
1. Boots
2. Sneakers
3. Pumps
4. Sandals
5. Flats
6. Oxfords

Accessories

Headwear
1. Hat
2. Beret
3. Beanie
4. Sunhat
5. Headband
6. Hair clip

Jewelry
1. Necklace
2. Bracelet
3. Earrings
4. Watch
5. Body piercing
6. Ring

Wearing
1. Glasses
2. Tall socks
3. Bow tie
4. Tattoos
5. Scarf
6. Belt

Carrying
1. Bag or backpack
2. Musical instrument
3. Book
4. Drink
5. Camera
6. iPad

Part 1: Building a Body

Make a skeletal frame

1. Start by drawing a line for the shoulders and hips. I like to angle these lines in different directions for a more dynamic pose. Draw a line for the spine, ovals to define the chest and hips, then the shoulders and hip joints. Draw the legs. Define the knees and ankles, then draw angled lines for the feet, going in different directions. Look back to page 37 to see how to construct feet. Next, pose the arms. Hands can be challenging if you're new to drawing people, so we'll put one of them into a pocket. For the other hand, draw shapes for the palm shape and thumb joint. Don't worry about drawing fingers for now. Use lines to form triangular shapes on top of the shoulders. Finally, draw the head shape. Use lines to define the middle of the face and eye line.

Draw the body base

2. On a new layer, sketch over the skeletal frame you just made, thickening up the torso and limbs. Be sure to keep the structure of the feet and hand on this new sketch. Draw your character's face. For this illustration, keep the features simple. Define the hairline and draw ears.

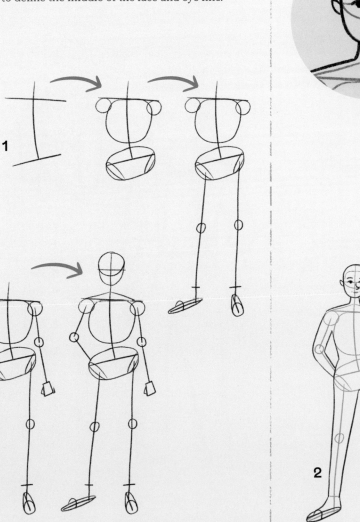

Part 2: Clothing & Accessories

Now it's time to play our character-making game. Grab your die and roll to determine what your character will look like and wear.

Sketch the Head & Clothes

1. Create a new layer to make your final sketch. Draw the shape of the hair, face, and facial features once more. Determine your character's hair length and texture and draw the shape of the hair around the face. Time to play dress-up! For my example, I rolled 'jeans' and 'T-shirt.' Using the body base as a guide, draw the articles of clothing, looking up reference photos to guide you. Give the clothes a little volume when needed. For example, these pants would seem skin-tight if I'd drawn them directly on top of the edges of the legs. Instead, I gave them a looser fit by drawing the lines a little further away.

2. If you choose to give your character outerwear, draw it on a separate layer. Then go back to the previous clothing layer and use a Layer Mask (see page 54) to non-destructively 'erase' any parts that are under the jacket. This way, you can change your mind if you want to dress your character differently. Next, draw the shoes. Use the contours of your foot construction to guide you, and check page 37 for tips.

TIP: Draw the details of the clothing, but don't overdo it. Try depicting an article of clothing in as few lines as possible.

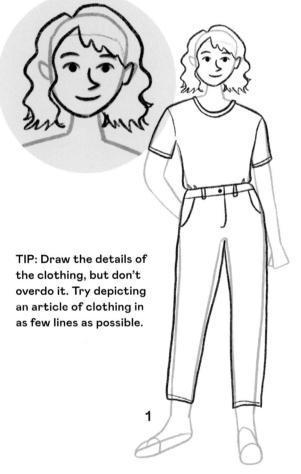

1

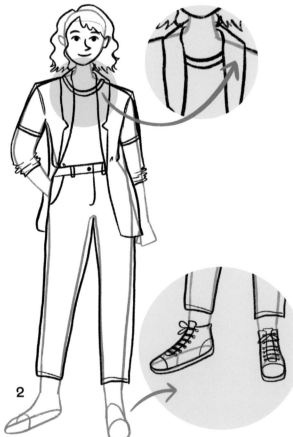

2

Accessorize!

3. What outfit would be complete without a few accessories? Add as few or as many as you'd like. Experiment with accessories by drawing them on their own layers. I rolled a 'beret,' but found that a hair clip worked better for my character. I also added glasses, an iPad, and tall socks. Finally, draw any remaining parts of the body, such as arms and ankles. Turn off your body base layer, and you're ready to move on to color.

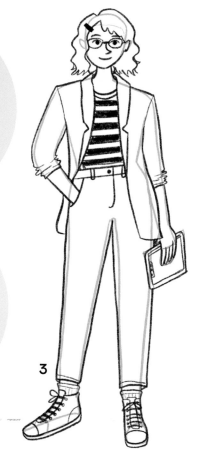

Part 3: Coloring Your Character

Make a Color Plan

1. Before making your final art, experiment with colors for your character's outfit. Create a new layer and draw shapes for each of the elements. As long as these shapes don't touch, you can use Color Drop to experiment until you're happy with color combinations. Save these colors into a palette for easy recall as you work on your final piece.

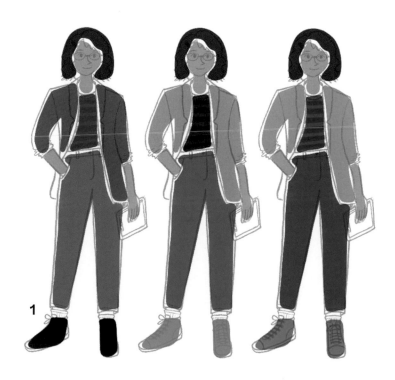

Draw the Elements On Separate Layers

2. Reduce the opacity of your sketch and select the Studio Pen brush (Inking set). Make a new layer underneath. Start by drawing the skin elements, the arms, legs, and neck. Draw the face on its own layer. Create a layer for each of the articles of clothing. Outline the shapes and fill them with Color Drop. Be sure to periodically turn off the sketch layer to see how things are looking. Continue making layers and drawing shapes for each element. Don't worry if parts of one element overlap another—you can correct all that in a moment. Draw the hair on a layer above the head. Make a layer behind the neck to add the background hair. Then make the hair shape a little more detailed by adding some stray hairs and tapered pieces.

Layer Clean-Up & Line Details

3. It's time to address those overlapping elements. You can make precise edits with the Selection tool. Select the layer of the element you wish to be visible, then select the contents of that layer. With the selection still active, tap to the layer of another element and erase within the selection. In my example, I wanted the arm to be visible over the blazer and jeans. I selected the contents of the arm layer, tapped over to the blazer layer, and erased that area. Then I tapped over to the jeans layer and erased there as well.

2

3

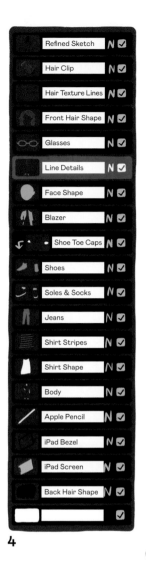

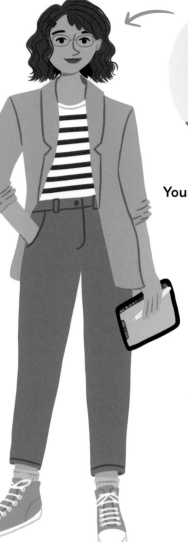

Your finished character!

Play again!
The character-drawing fun doesn't have to stop here—use the same body base and play again.

4. Finally, add the line details to this piece, starting with the head. Create a layer above the face layer. Draw the facial features and a shadow under the chin. Next, make a layer above the hair shape to add some simple texture lines to the hair. Create a layer above all the body layers to draw in the line details for the rest of the piece. Don't trace over every line in your sketch— use lines to define different shapes of the same color, as well as clothing details, such as stitching, wrinkles, shoelaces, etc. As a rule of thumb, if there is enough contrast between two elements, you probably don't need to add a line there. My character's blazer and skin tone are very similar, so I added a line for definition on the left arm. Continue adding line details. When you're all done, turn off your sketch layer, and your character is complete.

Making a Scene

Now that you've practiced drawing a lot of individual subjects, you might be wondering how to combine them into a bigger composition. In this chapter, you'll learn how to build and draw scenes. Scenes are a fun way to create a fanciful world, inviting viewers into your imagination, and giving you the opportunity to add unique details and engage in world-building.

The thought of drawing an entire scene can be overwhelming. This chapter is about learning the process of creating scenes, from deciding what type of scene you want to create and doing studies and visual brainstorms on the scene's components, to creating a layout, coloring, and rendering all the details. Once you've learned this process, you'll be ready to tackle any scene, whether it's a favorite room in your house, a bustling urban street, a beautiful wilderness retreat, or a fantasy location only your imagination can dream up!

How to Build a Scene: **The Process**

So, you've decided you want to draw an entire scene, but where do you begin? There are so many elements involved in constructing a scene. How do you know what to include? What is everything going to look like? Where should you put everything? By breaking down making scenes into a series of steps, you have a path to follow that will end in the creation of a complex illustration filled with lots of rich details. Read on for a detailed description of each step in the scene-building process.

Step 1: Determine Your Scene's Type

The first step in illustrating a scene is to decide whether it's nature-based, rural, indoor, or urban. There are as many different kinds of scenes as there are places on the earth (and beyond—space scene, anyone?), but we can generalize them into these four categories: Nature Scene, Rural Scene, Interior Scene, or Urban Scene. Understanding the type of scene you're creating will inform the research and sketching you'll do in the next step.

Nature Scene
A nature scene is a predominately natural environment with little to no human-made elements. A nature scene can be based on a particular environment or climate, such as desert, ocean, forest, jungle, etc.

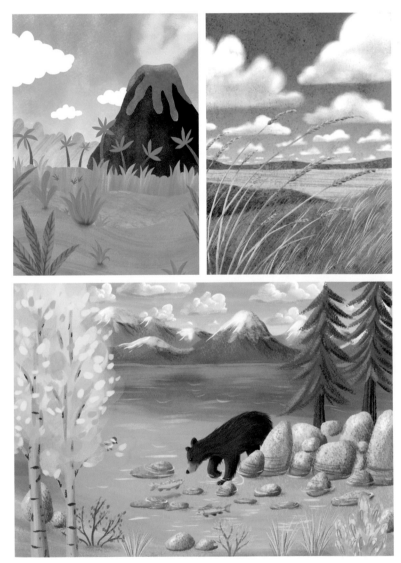

Rural Scene

A rural scene is mostly natural with one or two human-made elements, such as a farm with a barn, a garden with a greenhouse, a cabin in the woods, or a home in the desert. Or how about a treehouse?

Urban Scene

An urban scene is one based in highly populated areas, such as towns and cities. This could be a storefront, a street corner, or a cityscape. You could be depicting a world-famous city, or a sci-fi metropolis from the future.

Interior Scene

An interior is a scene set inside a house or building. There's a wide range of what this could be—anything from a living room, kitchen, or bedroom, to an office, grocery store aisle, or art gallery.

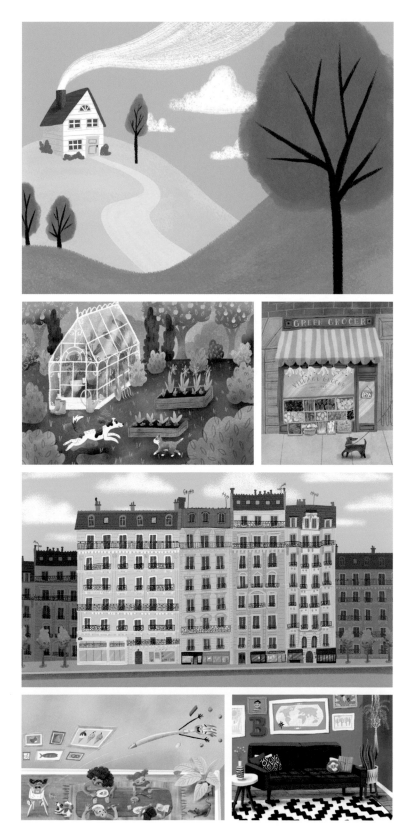

Step 2: Research & Sketch Your Scene's Elements

A big part of drawing scenes is research, brainstorming, and sketching. Think about what elements will go into your scene, then start looking up references and doing lots of sketches! This is also a great time to determine what kind of visual style you'll use for the piece.

Below are the different elements you should research for each scene type.

Nature Scene
Land formations
Water features
Plants and trees
Animals and creatures
Clouds and sky

Interior Scene
Furniture
Seating
Lighting
Decor items
House plants

Rural Scene
House or building
Doors and windows
Tools and objects
Plants and trees
Animals and creatures

Urban Scene
Building shapes and rooflines
Windows, awnings, and doors
Signs and window displays
Urban greenery
Vehicles

Examples of research sketches for an interior scene

Step 3: Lay Out the Elements of Your Scene in a Sketch

After completing your brainstorms, you now have a visual library of components to consider as you build your scene. It's time to put everything together!

First, lay out everything in a rough sketch using basic shapes. Generally, it's best if you begin by adding the most massive elements (like land formations, buildings, furniture,

etc.) and then incorporate the next largest, and so on until you've added the final details. With interior scenes, it's helpful to make a floorplan like the one below left.

Next, refine your initial layout sketch by drawing everything in detail. This is the stage when you'll depict everything as you want it to look in the final piece.

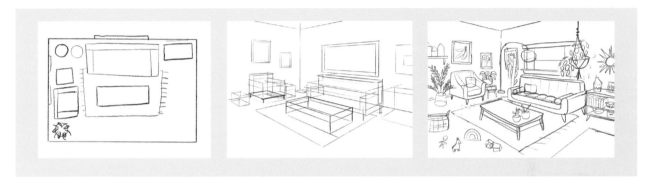

Step 4: Color & Render Your Final Scene

Finally, color and finish your scene. Start by blocking in colors, then add texture, details, and lighting. When you're done, pat yourself on the back for all your hard work, and admire your amazing scene.

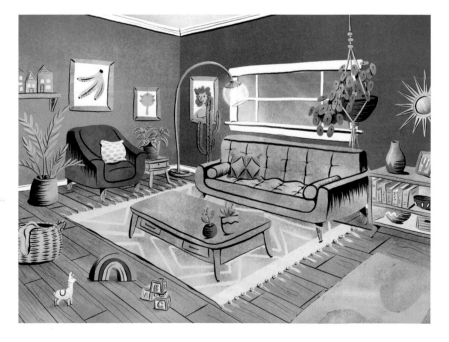

The last three projects in this book will take you through variations on this scene-building process. I'll provide example artwork and walk you through the steps of researching, drawing, and rendering each one, so that you can have a go at creating your own versions and variations from scratch.

Project: Skewed Perspective Tabletop

A big part of drawing scenes is having a good understanding of perspective, but you don't always have to depict a scene in perfect perspective. In fact, sometimes it's better not to. By utilizing a skewed perspective, you can show multiple angles simultaneously.

Look at these tables. Looking straight down from above gives you a good view of everything on the plates, but it would be tough to see anything else around the table. The second image has a lot of depth, but now you can't see the food. Let's draw something that marries these two perspectives. You can't take a top-down picture of a table while also showing what's on the nearby countertops and walls in real life, but you can in illustration. In this project, you'll be creating a tabletop scene while learning how to make the distorted perspective look cohesive.

Part 1: Planning & Sketching

Decide What's On the Menu

1. What kind of food will you be serving in your tabletop scene? It can be your favorite foods, dishes celebrating your culture, or maybe even an array of delicious desserts. Sketch out these foods before creating your scene so you can get familiar with how you'd like to portray them.

1

Choose An Artistic Style

2. You can finish your scene in any visual style you'd like. Painterly, semi-realistic, comic-style . . . the options are endless. I'll use a fairly simple visual style for my tabletop piece: flat colors with sketchy pencil details and shading. This is also an excellent project for embracing wonkiness—those wobbly lines and imperfections will add even more character to this already quirky scene.

Draw Your Tabletop

3. Begin your rough sketch by drawing your tabletop. Decide if it's square or round, whether you can see the whole thing or if it goes out of the frame, and think about what kind of legs it has.

Is this scene set in the kitchen, dining room, or an outdoor patio? Fill in the background with large pieces of furniture. In my example, I've drawn some kitchen counters, a window, a shelf, and a sink.

Fill the Table

4. You can now begin setting the table. Start by drawing the larger items, such as plates and serving bowls. Sketch simple 3D forms for the rest of the table's contents. Draw mounds in the bowls to show the volume of the food they contain.

The imaginary inhabitants of this scene will need a place to sit, so draw a chair using simple 3D rectangles. The chair's seat should be at approximately the same angle as the tabletop, but it doesn't have to match perfectly. Finally, sketch any items that may be on the surfaces in the background.

TIP: Draw these items on a layer separate from the table, and you can use the Select and Transform tools to move them around into a better arrangement.

Get Lost in the Details

5. Trace over your rough sketch to refine each of the elements. Have fun with things like wallpaper and furniture styles. Get creative—the details of your scene are what's going to give it the most character.

Make a Color Plan

6. With your refined sketch complete, take some time to experiment with colors by making a color plan using temporary layers.

TIP: Look to interior design photos you've got pinned to your inspiration board as you create the color palette of your scene.

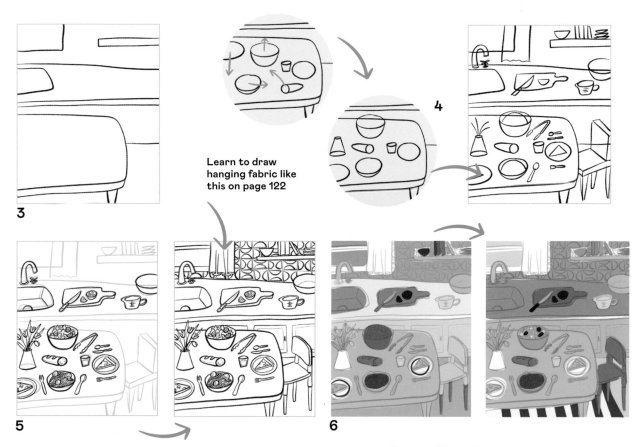

Learn to draw hanging fabric like this on page 122

3

4

5

6

Part 2: Blocking in Flat Color

Drawing Objects, Layer by Layer

1. Draw all the elements of your scene in flat color—I used Studio Pen (Inking set)—and remember to place any overlapping elements on separate layers. Start with the background. In my piece, the floor and counter are on one layer, and the wall and cabinets are on another.

2. Because there are a lot of elements in this scene, it's best to put as many things as possible on the same layer. Start with the 'lowest level'—draw all non-touching objects that would be on the bottom-most layer. Then make another layer to draw the parts that go on top of or touch the previous ones—the salad in the bowl, the pizza on the plates, the window frame, etc. Add another layer, if needed, for more details.

Some objects I put on my third layer were the food toppings, flowers, curtain, faucet, and shelf.

3. Once you've drawn all the objects, use Clipping Masks on those layers to add flat shading. This would be for things like the edges of furniture, the insides of dishes, food details, etc.

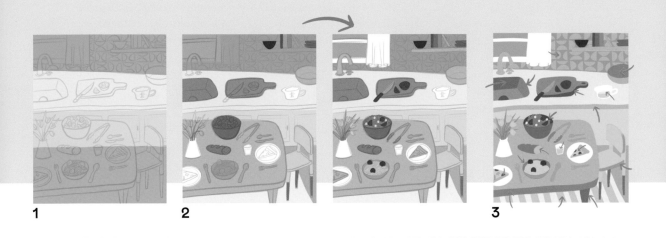

1

2

3

Part 3: Lines & Details

All these flat shapes are looking a little, well, flat. Time to add some linework and detail. For my piece, I wanted a sketchy, colored-pencil feel. So, I used just one brush for all the details and shading: Peppermint (Sketching set), a pencil-type brush. I used this brush to draw lines and make scribbly areas of color. I used Clipping Masks and Alpha Lock for some of these details, but I drew most of them on layers above all the flat color layers. I'll walk you through some of these details in my scene. As you'll see, you don't need

a lot of detail to make objects look 3D, transparent, shiny, or reflective.

Woodgrain

1. For the table woodgrain, I made a Clipping Mask over the table layer and rapidly drew many lines in light and dark variations of the table color. Then I used the 'Twirl' Liquify mode, with the Distortion slider turned up, and slowly brushed over the grain's direction to make it a little wavy. See page 31 for Liquify tips.

Spaghetti

2. I drew lots of curvy lines to make noodles on a layer over the spaghetti. Then I added light and dark shading to the meatballs. On the same layer, I shaded the front of the bowl and drew a light-colored line along the bowl's lip. Then, on a layer beneath that one, I scribbled in some orange to make it look saucier. Finally, I made a layer above the bowl to scribble a darker shade inside the bowl.

Salad

3. I used the same layers as the spaghetti to draw many other details in my scene, including this salad bowl. First, I shaded inside the bowl. Then I shaded the lip and front of the bowl. Finally, I drew the details of the lettuce and tomatoes.

Drop Shadows

4. Drop shadows under each object help them feel grounded on their surfaces. Start by scribbling a shape that is a shade darker than the surface. Then draw a darker, smaller shadow right under the edge of the object.

Glass & Water

5. Glass is transparent, but it's generally lighter than the surface it's on, so I started with white for the shape of the cup. Using a tint of the table color, I scribbled over parts of the glass to make it appear transparent. A couple of gray lines worked well for the dark parts of the glass. There's a lighting pattern to water in a glass, and I've done a simple version of that here. Look at reference photos to help you place shadows and highlights.

Shiny Surfaces

6. You can make flat surfaces look shiny with light-colored diagonal lines, as I've done on the wall tiles and window.

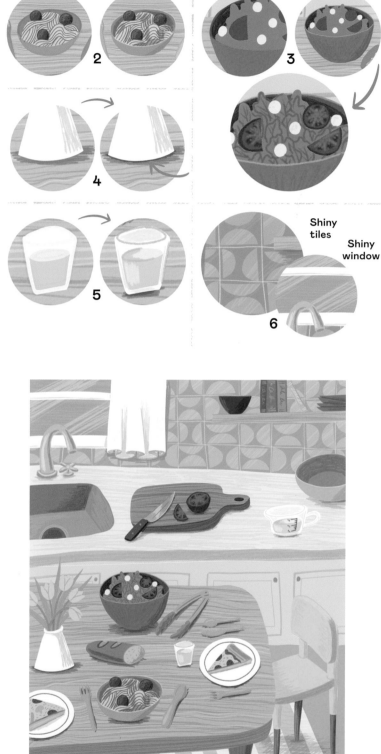

The finished table!

Project: Cityscape

For this project, you'll be tackling an urban scene. Cities are rich with detail, from the buildings and shops, signs, and displays, to the vehicles and all the people who inhabit them. Your cityscape could feature a single storefront or a plethora of city buildings. You could depict your favorite city from around the world or a favorite spot from your hometown. For the example I'll show you, I'm drawing an NYC-inspired street corner.

Simple windows

Windows, Awnings, Doors
How to Draw a Simple Window

Draw two thick horizontal lines, then connect them with vertical lines to form the window trim. Erase the ends of the horizontal lines to make sharp corners. On a layer under the trim, block in the glass color. On a layer between those two, draw the window rails or grilles. Then use Clipping Masks to draw the details.

Windows and doors

Building Shapes & Rooflines
Make Brick Quick

Create a base using a brick color. Make a Clipping Mask and draw horizontal lines. Make another Clipping Mask and draw vertical lines. Erase between every other line, then draw in the remaining lines to form the brick pattern. Go back to the first layer and enable Alpha Lock. Paint an overall texture using the Burnt Tree brush (Charcoals set) or similar. Then paint the individual bricks in various tints and shades of the base brick color.

Brickwork

Urban greenery

Rooflines

Buildings

Signs and awnings

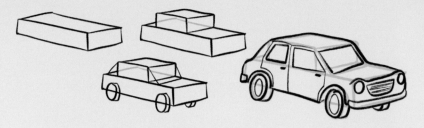

Vehicles
How to Draw a Car
Draw a 3D rectangle with another one stacked on top. Add angled lines connecting the two and draw cylinders for wheels. Trace over this structure with more curves and detail.

Part 1: Sketch & Color Plan

Now that you've completed your research and visual brainstorm, it's time to start constructing your cityscape.

1. Lay out everything in a rough sketch using basic shapes, starting with the largest elements. Begin by laying down the roads and sidewalks. Decide if you will draw in linear perspective or create a flat-oriented street scene. In my example, I'm doing a mix of both. Then draw the building shapes. Now draw the doors and windows. For large buildings, draw grid lines to indicate window placement. Finally, sketch any vehicles and urban greenery.

2. After you've added all the components to your scene, refine your sketch on a new layer. Reduce the opacity of your rough sketch, and trace over everything with more detail. In this step, you will nail down all the little details generated in the research phase. Define the shape and trim of windows, the design of storefronts, awnings, and signs, and any other details. Once your refined sketch is complete, it's time to color.

3. Before you start drawing the final shapes of your scene, make a color plan. This is a great way to experiment with what hues and values look good together before getting into the time-consuming work of shape-making.

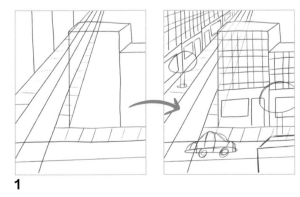

1

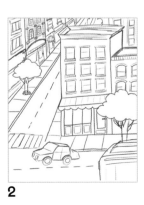

2

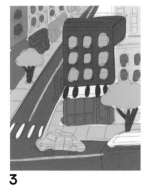

3

Part 2: Coloring

Block in the colors of the main shapes. As a reminder, it is good practice to place any shapes that touch or overlap on separate layers. In a scene with many different shapes and colors, you're likely to use many layers. I used Studio Pen (Inking set) for all the shapes except the tree foliage, for which I used Evolve (Drawing set).

1. Draw shapes for the streets and sidewalks first. Then draw the buildings, trees, and vehicles. Next, draw all the window glass—see the Tip for a quick way to do this.

2. On a layer above the glass, draw the window trim. Use the erasing method from the Tip to make this go faster. You can draw storefront façades on this layer as well. Use Clipping Masks to add additional coloring to the roofline.

3. Finally, create a layer between the glass and trim for the window rails and grilles. Use a contrasting color to make windowpanes.

4. Continue drawing more shapes for other details, such as signs, awnings, architectural elements, vehicle details, and street markings. At this point, you can turn off your sketch layer.

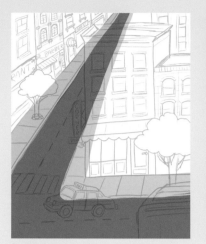

1a

1b

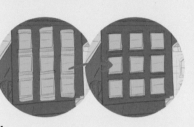

1c

2a

TIP: By drawing vertical rectangles and erasing the gaps between them, you can create columns of windows with speed and ease.

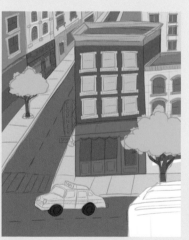

2b

3

4

Part 3: Texturing, Details & Shading

Let's add some texture to these flat shapes. Because all these elements are on their own layers, you can easily add texture with Alpha Lock and Clipping Masks.

1. Using Alpha Lock, apply an overall texture to all the shapes. I sampled each color with the eyedropper, then, with a slightly lighter or darker version of that color, I brushed on texture with a few different brushes: 6B Compressed and Burnt Tree (both from Charcoal set), and Artist Crayon (Sketching set). Diagonal brush strokes on the windows will create a subtle glass texture. Render surface textures by adding stone and brick patterns to some of the buildings. For a brick tutorial, see page 140.

2. Using a liner brush on a new layer, start working on the finer details. I did the linework for this piece entirely with the 6B Pencil (Sketching set). Add molding to the storefront façades, lettering and embellishments to the signs, details on the vehicles, window trimmings, awnings, and anywhere else that needs more finishing. You can turn your sketch layer back on as you add these details. Finally, use blend modes to add some shading. For this piece, I didn't add a lot of shading, but I did add shadows to the awnings, under the trees and taxi, and behind the main buildings.

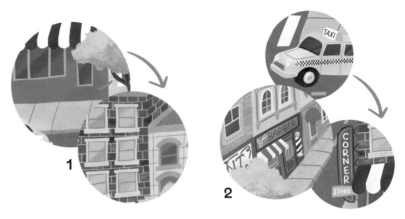

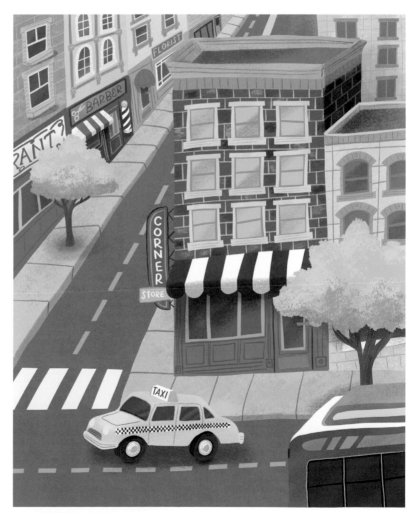

The finished cityscape!

Project: Nature Scene

Nature scenes are filled with organic details and are much less structured than the urban scene we drew previously. For this project, you'll use layering, placement, and atmospheric perspective to give the illusion of depth and distance.

The first step is to decide what type of natural environment you'd like to draw. There are so many options that would make beautiful illustrated landscapes. Why not choose a climate as a jumping-off point? Perhaps a desert, oceanside, forest, lake, or jungle. For my example, I'll be creating a tropical beach landscape.

Before you jump into drawing your scene, conduct some research and visual brainstorming for each element that will make up your nature scene. This time around, spend some time rendering your studies in full color to help you develop the visual style and pick out brushes you'll use in your final piece. I did many web image searches for things like 'tropical beach,' 'island vegetation,' 'tropical plants,' 'ocean waves,' 'waves on the shore,' 'tropical mountains,' etc.

Plants & Trees

For the plants, you'll want a variety of sizes. Large plants and trees will be focal points. Medium plants with striking shapes and colors will add visual interest. Finally, small filler plants will add lushness to the scene. These filler plants can be generic vegetation with textures that match the plant life in your environment. For these sketches, I looked up reference photos online, but I also used photos of interesting leaves and plants I'd taken on a trip to Hawaii a few years ago.

Large plants

Medium plants

Filler plants

Water Features

Be sure to do some full-color studies. While rendering the water elements of my scene, I discovered that the Hartz brush (Artistic set) was perfect for the texture of cresting waves and splashing water.

Animals & Creatures

Animals can play a small role in your scene, or they can be the main characters—it's up to you! Research what kinds of animals inhabit the environment you've chosen. In this tropical setting, some options are crabs, birds, sea turtles, sharks, dolphins, and other sea creatures.

Animals & creatures

Land Formations

What land formations are characteristic of the environment you've chosen? Here are some ideas: mountains, hills, dunes, cliffs, rocks or boulders, canyon, volcano, island.

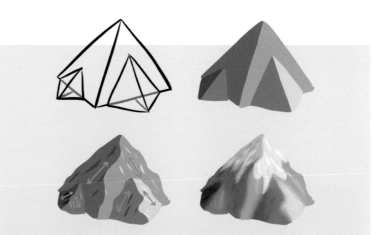

Mountains & Land Formations Demystified

If drawing mountains has always baffled you, I find it helpful to think of them as interconnected pyramids. This helps you see where the shading should go. The direction of additional details should go up and down each mountain face (see arrows). When drawing mountains, follow this structure, but use more jagged, organic curves and soften the shading.

How to Paint Clouds

Start with a gradient sky, making it dark and cool at the top and light and warm near the horizon.

1. Paint cloud shapes with a textured brush. Due to perspective, clouds get smaller closer to the horizon, so your largest clouds should be at the top of the canvas.

2. Paint a darker value over the cloud, leaving the white around the top and side edges visible.

3. Add dark shadows along the bottom of the cloud shapes.

4. Come back with bright white, and paint highlights on the edges of the 'puffs' closest to the light source.

NOTE: Clouds come in many different colors, depending on the time of day and weather. Look at reference photos for color inspiration.

Part 1: **Setting the Scene**

Once you've completed your visual brainstorming for all the elements of your nature scene, it's time to put everything together. In this first step, you'll assemble the components, draw a detailed sketch, and determine your scene's color palette.

1

Lay of the Land

1. Place the elements of your scene into a composition using loose lines and basic shapes. Draw a horizon line, then position the land formations. Next, add the water features; I inserted a breaking wave and ripples.

Draw in Plants & Trees

2. The next step is to arrange plants and trees in your scene. Placing large trees in the foreground can help frame the scene and give it more depth. Then, fill in medium plants and filler foliage.

Add Sky Elements & Animals

3. Next, you'll add clouds or other sky elements. Finally, place any animals you've decided to include in your scene.

Draw a Refined Sketch

4. Once you've laid out all the elements, trace over your rough sketch with more detail. Draw everything as you'd like it to appear in the final artwork. When you've completed your refined sketch, it's time to color.

Make a Color Plan

5. Make temporary layers and loosely brush in colors to create an overall color palette. I was inspired by the cloud studies I made in my research, so I decided to depict my tropical scene at dawn, creating a soft, pastel palette.

2

3

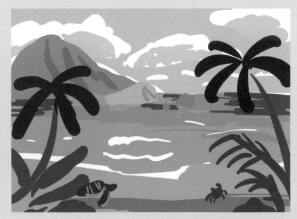

4

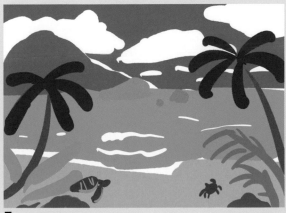

5

Part 2: Laying Down Flat Colors

In this step, you'll make layers and draw the flat shapes of each component of your scene, paving the way for rendering in the next phase.

Draw the Background Elements

1. Begin coloring the main shapes, using multiple layers to separate overlapping elements of your scene. Start with the bigger background elements first, then add smaller land formations. I used Mercury (Inking set) for the water and islands, layering lots of strokes to add texture. For the sand, I used Spectra (Painting set).

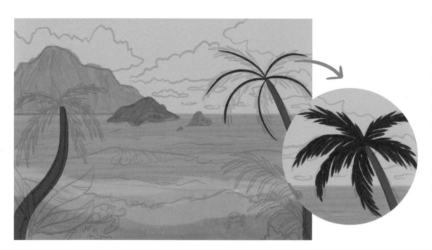

Foreground Plants & Trees

2. Next, draw the foreground elements, again separating everything into layers. I used the Dry Ink brush (Inking set) to draw my plants and trees. To create the palm fronds, I used lots of quick, flicking motions, taking advantage of this brush's tapered strokes.

Sky Elements

3. Create a layer and paint in the shapes of the clouds. I used the Hartz brush (Artistic set) for my clouds. It's got a great texture and variations in opacity.

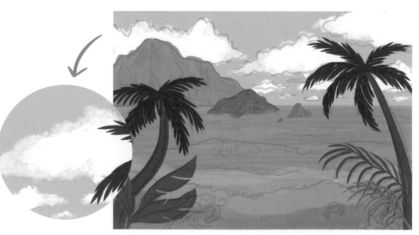

Part 3: **Rendering Elements**

The next step is to render all the elements in your scene with texture, details, and shading. I'll walk you through how I rendered each piece of my scene. This part is usually the most time-consuming, but take it one element at a time, and you'll end up with a beautiful, fully rendered illustration.

Water

1. Add texture and shading to the water elements. To create a gradient, I enabled Alpha Lock and used the Soft Shading* (free brush download, see note on p46) to add soft strokes of light blue and purple tones. Then I used strokes of Mercury (Inking set) to add texture back to the water. I used Dry Brush (Painting set) to lightly add some water ripples, using a smaller brush size near the horizon and a larger size near the shore to give the impression of distance.

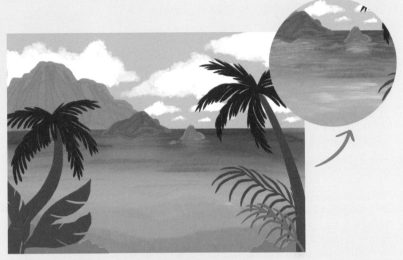

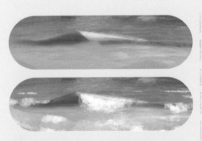

Waves

2. Recalling my water studies from the visual brainstorm, I painted the light and dark parts of the breaking wave. Then I used Hartz (Artistic set) to paint the wave's white crest. I also used Hartz to paint the waves lapping the shore and a few other places in the water.

Sand

3. I added texture to the sand using the 6B Compressed brush (Charcoals set), layering strokes in light and dark colors. I also added a little cast shadow under the shore water.

Islands

4. I used the Aurora brush (Artistic set) to add texture, color variations, and shading to the islands, establishing my light source coming in from the right. To make the big island appear farther away, I made it lighter and less vibrant, employing the principles of atmospheric perspective. I also layered in warm colors to reflect the golden morning light. See page 145 for tips on shading mountains. I rendered the small island and rocks with more contrast and vibrancy.

Palm Trees

5. Using a Clipping Mask, I used a lighter, warmer green and the Dry Ink brush (Inking set) to draw strokes along the leaflets of each palm frond. Then I used Soft Shading* (free brush download, see note on p46) with the Smudge tool to make strokes in the direction of the palm fronds to soften the lines. Finally, I added shading using another Clipping Mask along with the Multiply blend mode.

Tree Trunks

6. For the trunks, I used Alpha Lock to add light and dark shading. Then, on a Clipping Mask set to Multiply, I drew some lines contouring the trunks, then softened them with the Smudge tool.

Plants

7. For the plants on the right, I used the same technique as for the palm trees, adding lines with a Clipping Mask, smudging them, then using a blend mode to add shadows.

Floor Vegetation

8. Over on the left side, I shaded the big leaves using Alpha Lock, then used a Clipping Mask set to Multiply for the lines, again smudging them to soften.

Larger Leaves

Using Hartz (Artistic set) and Dry Ink (Inking set), I added texture and blades of grass to the floor vegetation.

Clouds

9. I started by using Soft Shading* (free brush download, see note on p46) to add soft strokes of light orange, yellow, and purple to the sky. Then I used Hartz (Artistic set) to layer on the colors of my clouds. See page 146 for tips on painting clouds.

Animals

10. I used two layers to draw the turtle in Dry Ink (Inking set), one for the shell and one for the head and flippers. I used Alpha Lock on each layer to paint the details using Soft Shading* (free brush download, see note on p46). Finally, I shaded the shell using Clipping Masks in combination with blend modes. With 6B Compressed (Charcoals set), I added a shadow beneath the turtle.

11. For the crab, I followed the same steps.

Final Touch-Ups

12. After taking one last look at the piece, I decided some things looked too crisp compared to the more painterly style of the clouds and sea, so I used the Smudge tool to soften the islands and the edges of the trees and leaves.

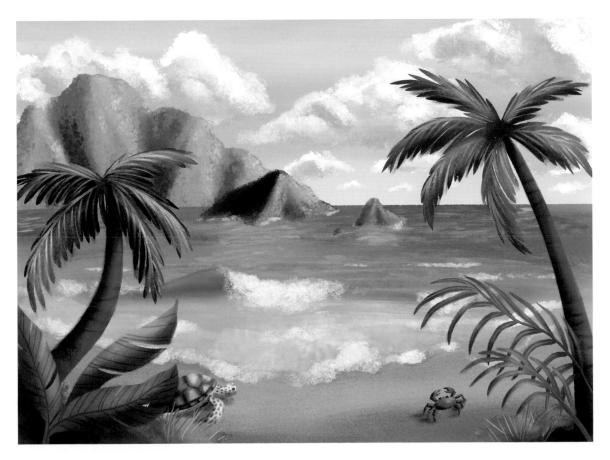

The finished nature scene!

8
How to Draw Everything

It's safe to say you've gained some serious skills by working your way through this book so far! Along with learning the foundations of drawing with line, shape, and 3D form, you've developed the muscle control to draw smoother curves and contours. You've gained technical expertise in using tools, such as layers, brushes, blend modes, masks, and more. You've honed your color-combining abilities through studying color theory and picking palettes. You've discovered that in order to draw from your imagination, you must first look to references. You put your people skills to the test to create your own characters. You've learned to render textures like fur, water, brick, and wood. You explored a diverse range of subject matter, drawing everything from simple objects to complex scenes.

You should be SO proud!

As we conclude this book, we will review the most important lesson you've learned thus far, equipping you to go forth and create digital masterpieces that are uniquely yours.

How to Draw Everything

The most important thing you can learn from this book isn't any one drawing tip or software trick. What matters most is understanding the process you've spent this entire book learning: how to take an idea from your head and turn it into a digital work of art. For everything you illustrate, you'll follow this same pattern of observing the thing you want to draw, breaking it down into its most basic form, and then building it back up by progressively adding more detail.

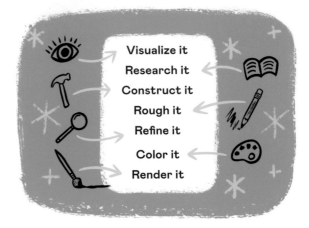

Visualize it
Research it
Construct it
Rough it
Refine it
Color it
Render it

Visualize It

1. Once you've decided what you want to draw, visualize what the finished artwork will look like in your mind. Think about the angle of view, composition, and style.

Research It

2. Look at many references, in photos or the real world, to gather information about the subject's appearance and characteristics. Research all the little details you might use to enhance the character of your illustration.

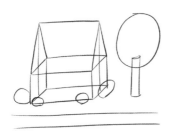

Construct It

3. Analyze the subject by breaking it down into basic shapes. Consider the proportions of each part of your subject and decide if you want to exaggerate anything. Then draw a structure by combining 2D shapes or 3D forms.

Rough It

4. Lay the foundation for the details you'll draw in your final sketch. Create a rough sketch of every element, drawing extra curves and specialized shapes. Add guidelines to assist you in drawing the final details.

Refine It

5. Trace over your rough sketch to create a detailed, refined sketch. Draw everything carefully, adding every detail you'd like to see in your final piece.

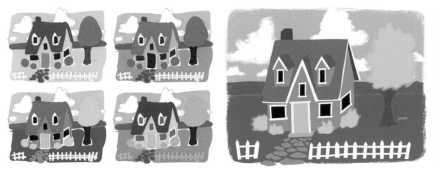

Color It

6. Determine your color palette by making a color plan: using temporary layers, block in color loosely, then experiment with different hues and values. Then draw each element of your subject in flat color, separating overlapping parts into layers.

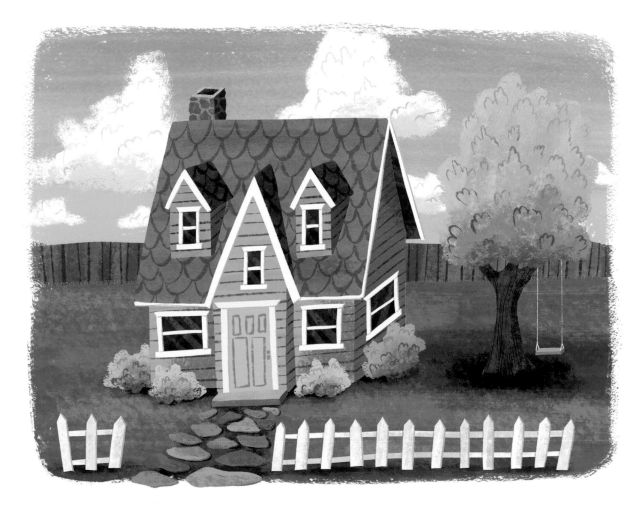

Render It

7. Transform flat shapes into real-looking objects with value and color. Use brush strokes, line detailing, and textures, plus the digital art tools at your disposal, such as Alpha Lock, Clipping Masks, and blend modes, to depict texture, create shading and dimension, add interesting details, and enhance visual impact. Polish your piece and make it shine.

What will you draw next?

Once you know the process of drawing, it's only a matter of time spent developing the skills within each step. With practice, you'll get better at visualizing the forms needed to construct something, and you'll gain better hand control when drawing lines and shapes. You'll become proficient with the software, knowing when and how to use each digital art tool. You'll get faster at picking pleasing color combinations and know what brushes you need to use to render specific textures. And, most importantly, you'll develop your own artistic style, knowing exactly what details to add to make your artwork sing.

Happy artmaking!

—Lisa

Resources

There's More to Learn!

Procreate Handbook // procreate.com/handbook

Created by the Procreate team, this in-depth user guide covers absolutely everything about using the Procreate app.

Art Maker's Club // artmakersclub.com

A joy-filled learning hub for digital artmakers, featuring a growing library of in-depth courses, live virtual events and tutorials, exclusive brushes, and a supportive and uplifting community of learning artists.

Bardot Brush // bardotbrush.com

Lisa is one of the leading brush-makers for Procreate, and the owner of Bardot Brush—the place for premium Procreate brushes that inspire creativity, plus free artmaking tools and resources.

Making Art Everyday // makingarteveryday.com

Join the ongoing artmaking challenge! Making Art Every Day is a series of daily drawing prompts, tutorials, and motivation to help you overcome creative fears and establish a daily artmaking practice.

Lisa's YouTube Channel: youtube.com/bardotbrush

For free tutorials about drawing, illustration, and all things Procreate.

Follow Lisa on Social Media

@lisabardot // @bardotbrush // @artmakersclub

Index

Acknowledgments

I could not have written this book without the endless patience and unwavering support of my husband, Geoff. You have always believed in me and celebrated my creativity while loving me wholeheartedly. It was you who gave me my first iPad, igniting this artistic adventure. You've diligently been by my side and let me fly when I needed it. As I worked long hours and late nights to complete this book, you took on way more than your fair share of family responsibilities, and comforted me through many panicky episodes along the way. Thank you for everything, especially for dreaming the big dreams with me.

To my children, Bear, Ellie, and Alfie: thank you for being an endless source of inspiration, hugs, and kisses. Your big hearts and creative minds have taught me more lessons than you could imagine. Never forget how brilliantly you shine.

Thank you to my family, especially my mom, for all the art books and craft supplies she provided, nurturing my love of creativity; my dad, for teaching me to put my all into everything I do; and my Grandma Burr, who shared with me her home and let me spread out and make a mess.

Special thanks go out to the team at Octopus Press, especially my editor Ellie Corbett. Your enthusiasm in approaching me to write this book was infectious, and I thank you for believing in my work and trusting me to bring it to fruition.

Thanks to all my friends for cheering me on, especially Rene Wootton, Brooke Glaser, Jessica Terry, and Laura Plouzek. And to Sam Aker, my right-hand gal and enthusiastic cheerleader.

Finally, thank you to all the people who have watched my videos, taken my classes, purchased my brushes, or participated in the pursuit of nurturing a creative practice by following me on this journey. None of this would be possible without you. It has been your stories, your excitement, your creations, and your words of encouragement and appreciation that have kept me going, creating, learning, sharing, and teaching. Thank you for joining me in the vulnerability that creativity demands. I am forever grateful for each and every one of you.

This book is dedicated to anyone who's ever said 'I'm just not creative' while an artistic ember lingers in their hearts. Together we can fan that spark into a flame.